TEXAS

Gulf Coast

impressions

Photography by KAC Productions · Text by Gary Clark

FARCOUNTRY PRESS

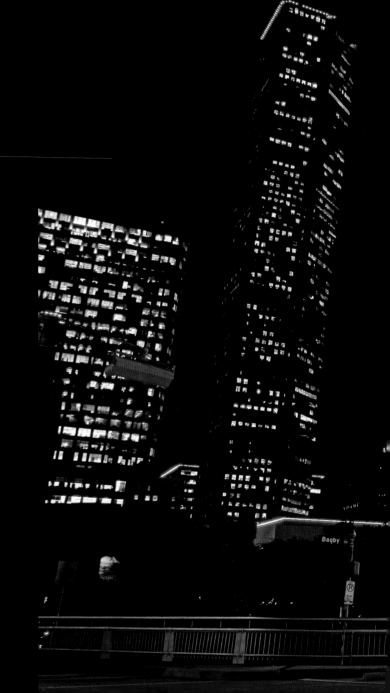

Above: The City of Galveston installs plaques commemorating historical landmarks such as Ashton Villa, a home built in 1859. Ashton Villa is one of several homes on the south end of Galveston's historic Broadway.

Right: Seen from Buffalo Bayou, the sparkling Houston skyline reaches into the night.

Title page: Galveston's famed beaches draw recreationists and sun worshippers alike.

Cover: A baby Kemp's ridley sea turtle makes its way across the sand to the Gulf of Mexico. Baby sea turtles face perils of predation from gulls, crabs, and raccoons.

Back cover: The Wortham Fountain in downtown Houston's Tranquility Park was designed to resemble rocket boosters. The park honors the Apollo flights to the moon and was named after the Sea of Tranquility, site of the first moon landing.

ISBN: 978-1-56037-410-7

© 2007 by Farcountry Press
Photography © 2007 by KAC Productions

For more information about our books, write Farcountry Press, P.O. Box 5630, Helena, MT 59604; call (800) 821-3874; or visit www.farcountrypress.com.

Created, produced, and designed in the United States.
Printed in China.

12 11 10 09 08 07 1 2 3 4 5 6

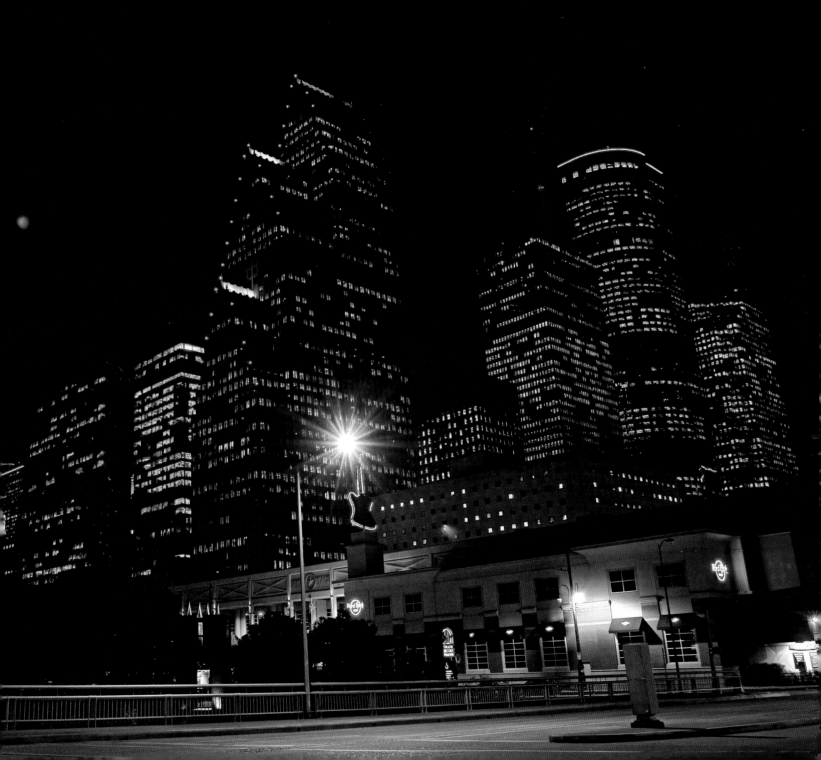

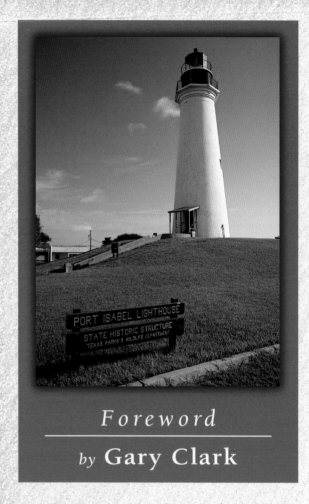

Foreword

by **Gary Clark**

Above: Constructed in 1852, the Port Isabel Lighthouse stands as the main attraction at the Port Isabel Lighthouse State Historic Site.

Facing page: The three-masted, tall sailing ship *Elissa* sets sail for an afternoon outing. Originally built in 1877 in Aberdeen, Scotland, the ship was restored by volunteers between 1977 and 1982 and is now docked at the Texas Seaport Museum. The National Trust for Historic Preservation designated the ship as one of "America's Treasures."

The Texas coast resembles a crescent moon as it stretches 397 miles across the state from Mexico to Louisiana. With its bays, river mouths, beaches, and barrier islands, the coastline seems to ease into the Gulf of Mexico like a hand slipping into a glove.

Coastal Texas is not a startling place. The sea does not crash abruptly against craggy rocks as it does at California's Big Sur, nor does it wash over vast expanses of bright-white sand as it does in Florida. The Texas coast does not arrest attention with dramatic scenery but rather lures attention with campestral landscapes.

Extending 60 miles inland, the coastal landscape starts at sea level and never rises more than 500 feet. Prairies along the coast provide a horizon-to-horizon view, part of the Texas heritage of wide-open spaces. Inland prairies also have wide vistas yet often undulate gracefully, like ocean waves. Coastal prairies occupy 200,000 acres and spread across several national wildlife refuges, which offer sweeping views and stunning sunset scenes.

Meandering across the prairies and toward the coast are eight major rivers. Among them is the Sabine River, which flows 555 miles through the northeastern portion of the state, forming the southern boundary between Texas and Louisiana. The San Jacinto River flows a mere 42 miles from the Sam Houston National Forest in east Texas, but it marks at its mouth the San Jacinto Battlefield, where Texas independence was won from Mexico in 1836. The Rio Grande is the fourth-longest river in the United States, traveling 1,885 miles from Colorado down through New Mexico and across Texas to form the border with Mexico, then languidly empty into the gulf at Brownsville.

A key feature of the coastal landscape is its seemingly endless marshes, beginning just west of Sabine Pass near the Louisiana border and blanketing the coast all the way to Brownsville. The marshes form a transition from land to sea. Marshes filter sediments in the water draining off the land into bayous and rivers; and, more importantly, marshes afford a bountiful nursery for such marine life as finfish, oysters, shrimp, and crabs. These ecosystems draw scores of beautifully plumed egrets, herons, and other birds, including the rare and endangered whooping cranes that spend every winter in the marsh at the Aransas National Wildlife Refuge on the central coast.

Indeed, birds are so plentiful along the Texas coast that they attract birdwatchers from all over the world, which is what prompted the state to design the 400-mile-long Great Texas Coastal Birding Trail that runs from Beaumont to Brownsville. In the spring, when Texas shores harbor the largest concentration of neotropical migratory birds in the Western Hemisphere, birdwatchers descend by the droves on coastal communities.

The bays and inlets that carve the coastline are rich in beauty and resources. If the picturesque bays and inlets were taken into account when

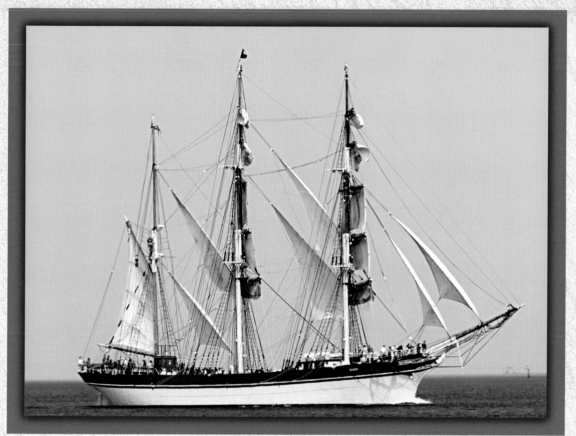

coast, and the industry's plants and refineries produce two-thirds of the nation's petrochemical products. Not surprisingly, petrochemical plants are as much a part of the coastal landscape as bays, marshes, and prairies. Visitors to the state are sometimes appalled by the stark steel tubes, fire-breathing cylindrical towers, and giant tanks that characterize the petrochemical plants dotting the coastline. But the industry drives the economy of America and, to some extent, the world.

Despite its bustling refineries, the Texas coast is a magnet for tourism. Two coastal barrier islands called Galveston Island and Padre Island draw multitudes of tourists. Galveston has everything a coastal tourist could ask for, including clean, sandy beaches, major historical sites, fishing piers, a serene state park, a fun-filled theme park, plenty of hotels and restaurants, and a quaint New Orleans–style shopping district. Padre Island, the world's longest barrier island, is a paradise for beach lovers, with vigorous surf and white, sandy shores rivaling Florida's coastline. Although South Padre Island has become a world-class resort, 80 miles of the 110-mile-long island host one of the most important and diverse wilderness areas in the nation: the Padre Island National Seashore.

The Texas coast has nooks for guests who look for out-of-the-ordinary places, solitude, or adventure. With nearly 400 miles of uncommon coastline trimming its hem with the gulf, the state can honestly brag, there's no place like Texas.

measuring the mileage of the coast, it would extend 3,359 miles. Among the bays that sculpt the coastline are Sabine Lake, Galveston Bay, Matagorda Bay, San Antonio Bay, Corpus Christi Bay, Copano Aransas Bay, and the Upper Laguna Madre. The fish in these bays attract hordes of amateur anglers and scores of commercial fishing vessels. In fact, fishing in Texas bays is a billion-dollar industry, with the shrimp harvest putting the state in the number three spot behind Alaska and Louisiana for U.S. shrimp production.

However, no industry along the Texas coast can match the oil and petrochemical business. Ever since the discovery of oil at coastal locations in the early twentieth century, Texas has virtually dominated U.S. oil production. At least a third of the nation's petroleum facilities are situated along the Texas

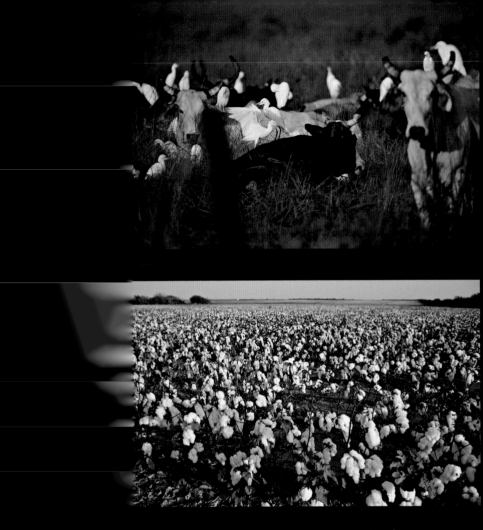

Above, top: Cattle egrets hitch rides on the backs of cows in a coastal prairie.

Above, bottom: Texas is the number one producer of cotton in the United States. First grown by Spanish missionaries in the 1700s, cotton now accounts for $1.6 billion in revenue for Texas farmers.

Right: Migrant farm workers tend crops in the Rio Grande Valley

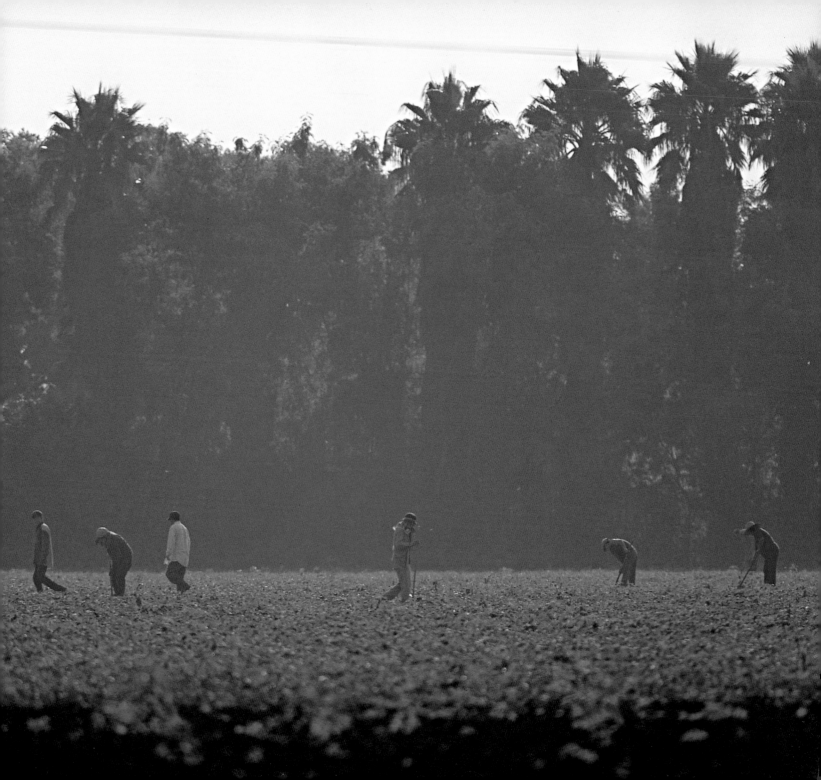

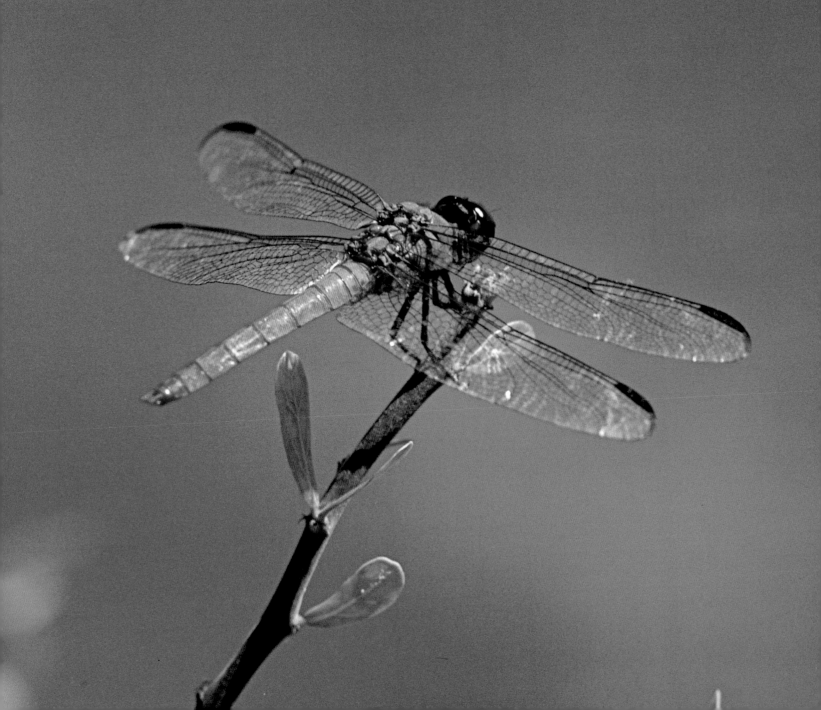

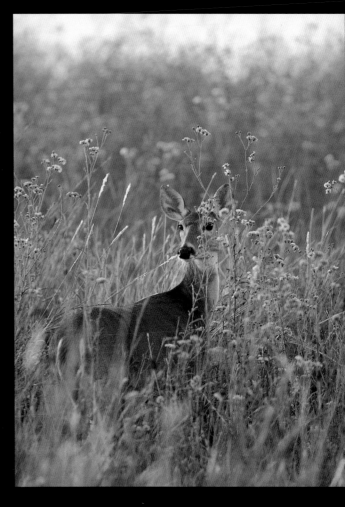

Above: A white-tailed deer doe makes her way through a field of tall grass and wildflowers.

Left: Beautiful dragonflies called roseate skimmers inhabit the coastal waterways and ponds during most of the year.

Right: Accustomed to the presence of humans, pelicans preen while resting on mudflats at sunset. People and wildlife peacefully coexist along much of the Texas coast.

Below: This least bittern perches inconspicuously on coastal marsh cattails.

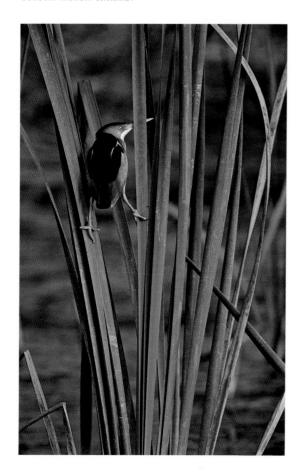

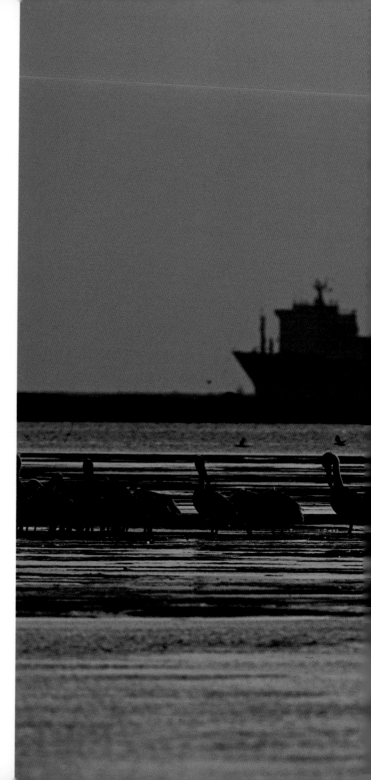

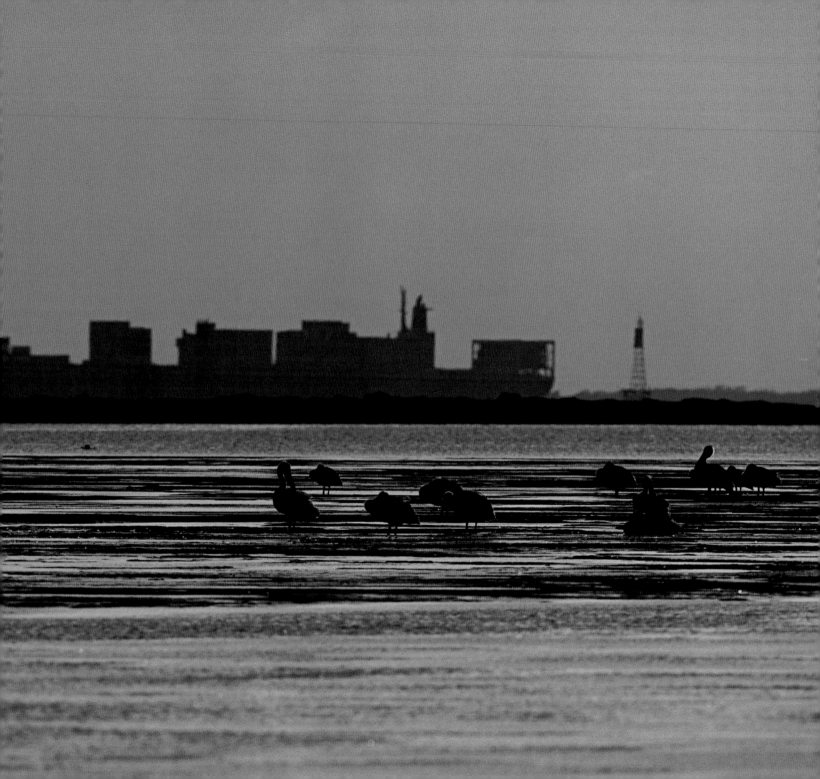

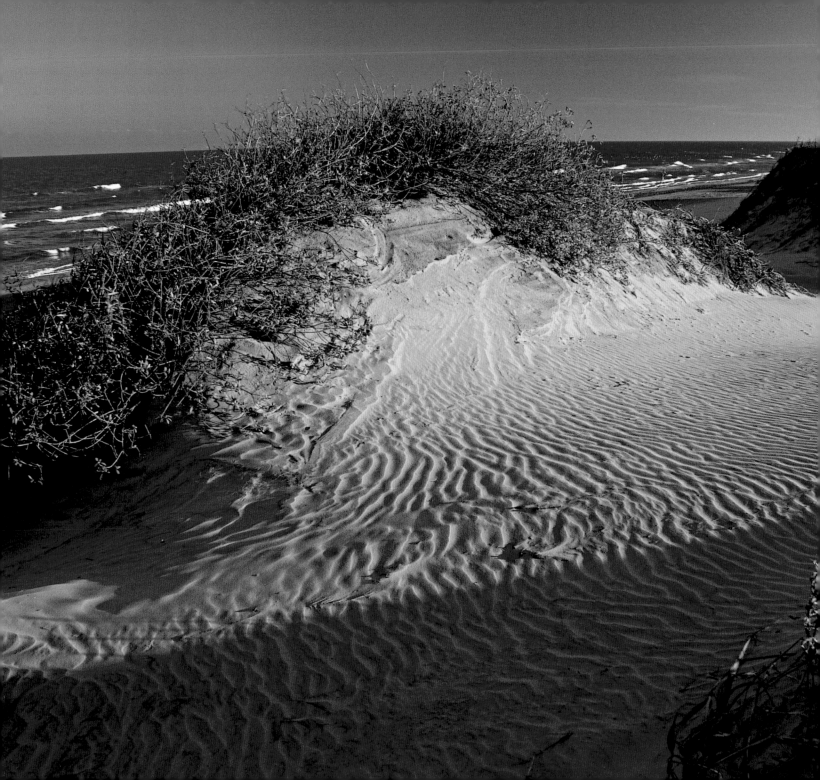

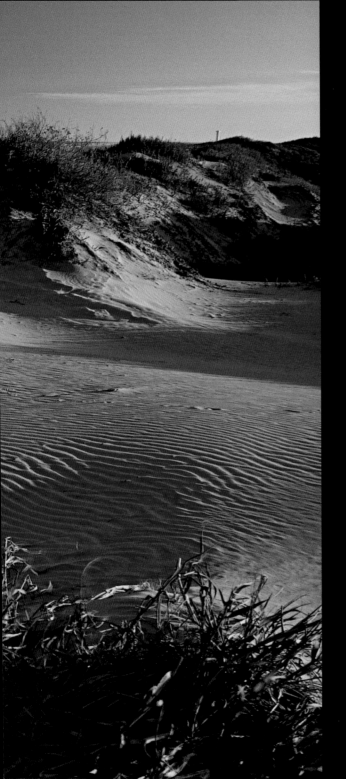

Above: The east end of Galveston Island draws large numbers of visitors throughout the year for fishing, birdwatching, and water recreation.

Left: One of the best-kept secrets along the Texas coast is Boca Chica Beach, with its expanses of gently rolling dunes and wide-open spaces lying east of Brownsville at the mouth of the Rio Grande.

13

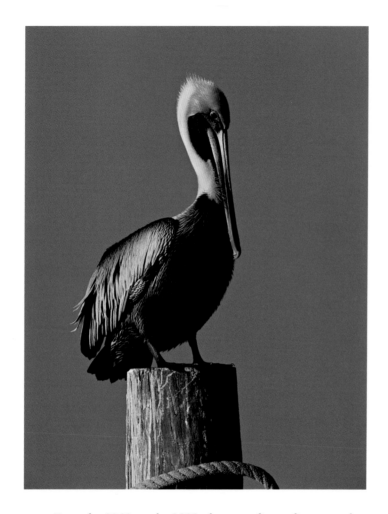

Above: From the 1960s to the 1980s, brown pelicans disappeared from the Texas coast except for a remnant population near Brownsville. The pesticide DDT, finally banned in 1972, devastated the brown pelican population. Since 1990, brown pelicans have made a remarkable comeback.

Right: Kiteboarding and other water activities draw thousands of visitors to Texas beaches each year.

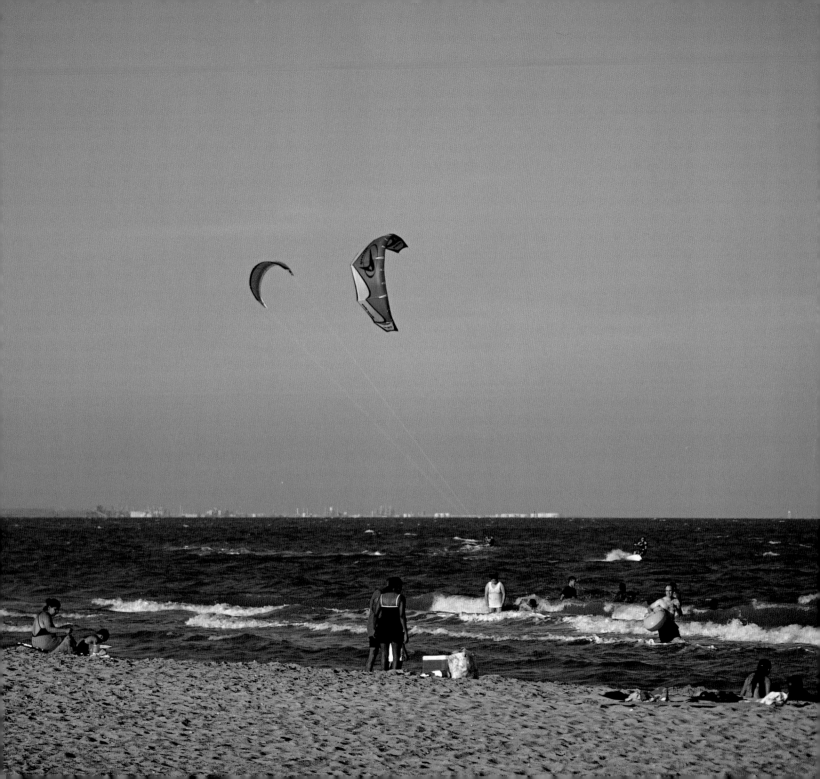

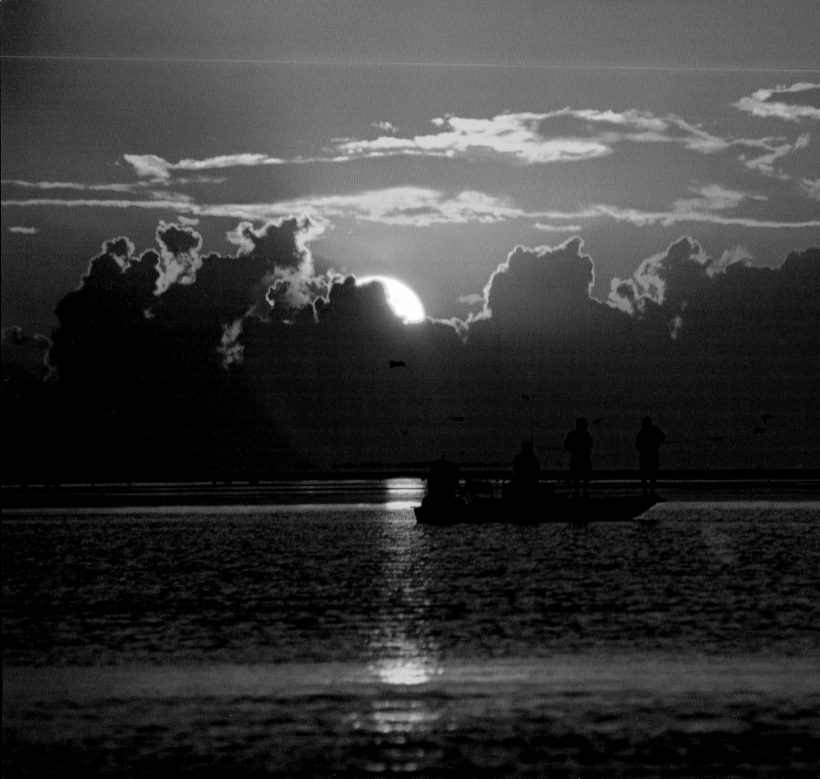

Left: Texas coastal waters are replete with speckled trout, red snapper, flounder, and many other species of fish.

Below: This female ruby-throated hummingbird is feeding on Texas lantana. During the fall, millions of ruby-throated hummingbirds gather on the Texas coast to feed and put on weight before the long migration to Central America.

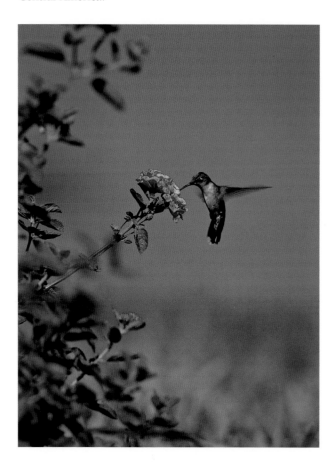

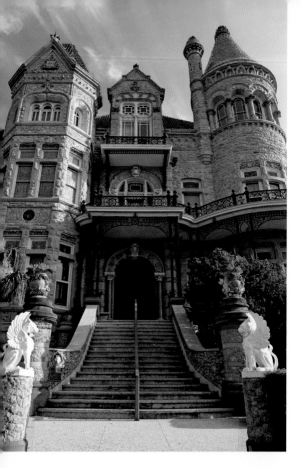

Left: Walter Gresham built the Bishop's Palace on Broadway in Galveston between 1887 and 1892. It survived the great hurricane of 1900 because of its steel frame surrounded by limestone, granite, and sandstone.

Right: Fulton Mansion, completed in 1877, stands at the Fulton Mansion State Historic Site, operated by the Texas Parks and Wildlife Department. The house overlooks Aransas Bay in Fulton.

Below: Ashton Villa, built in 1859, survived the hurricane of 1900 because of its cast-iron frame. Today, the home is a museum that some in Galveston say is haunted.

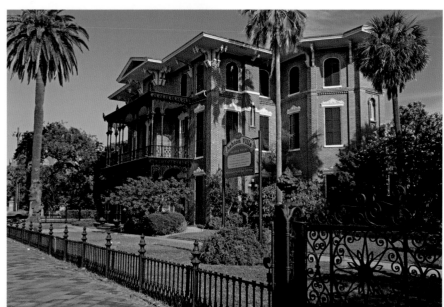

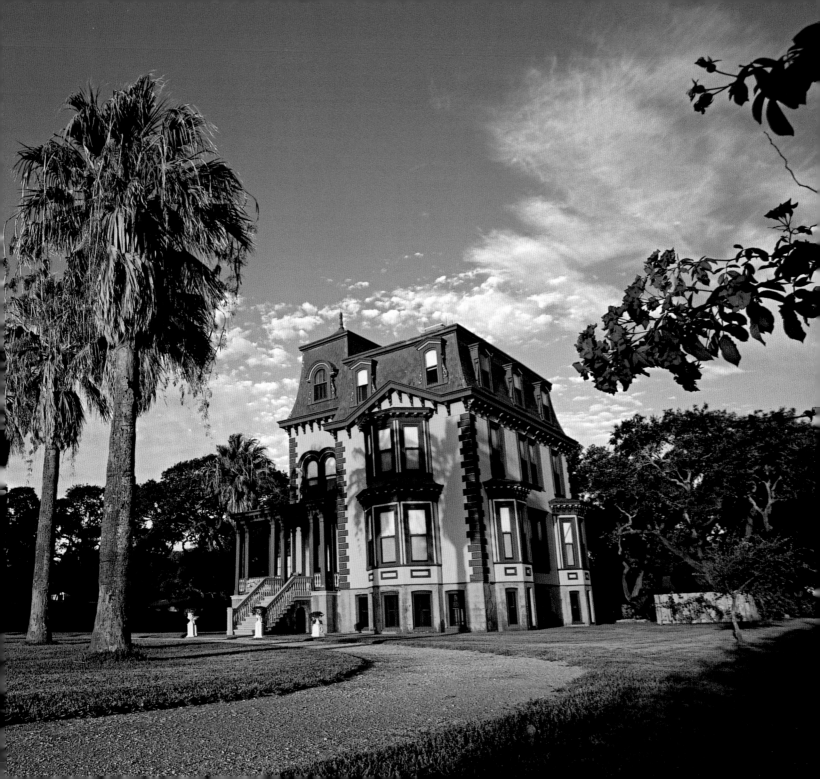

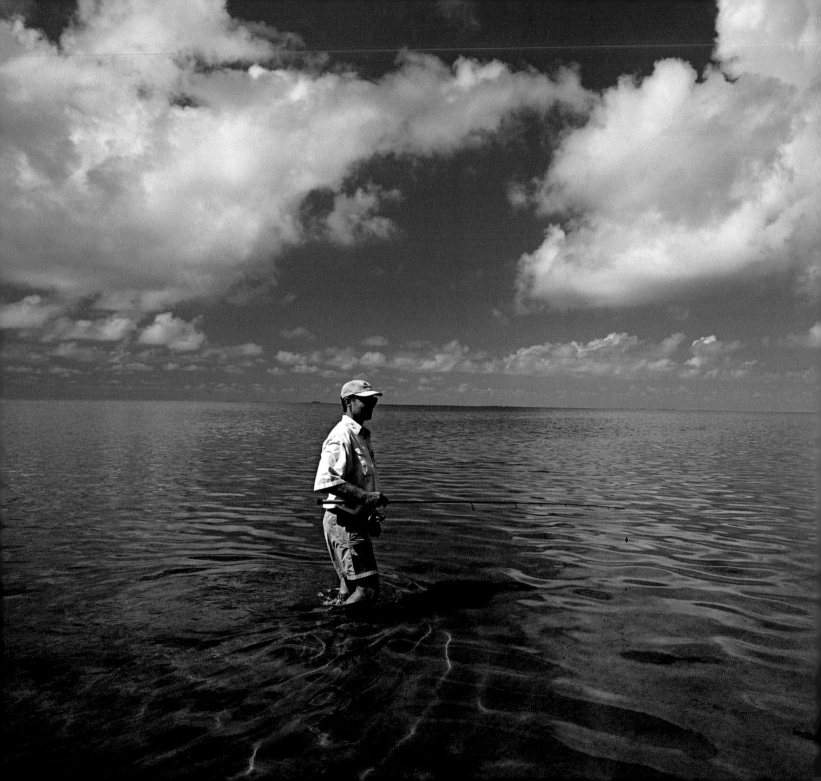

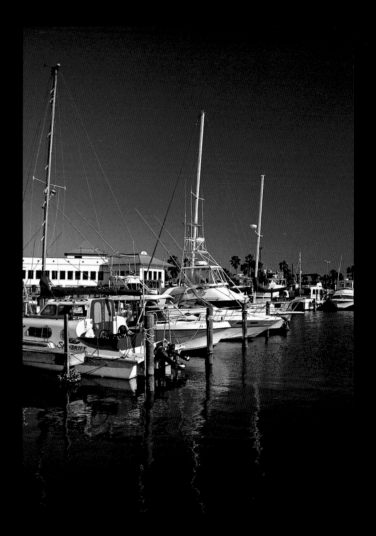

Above: Powerboats and sailboats sit ready for adventure in Texas waters.

Left: Shallow waters along the Texas coast offer excellent opportunities to fish for speckled trout, redfish, flounder, and snook.

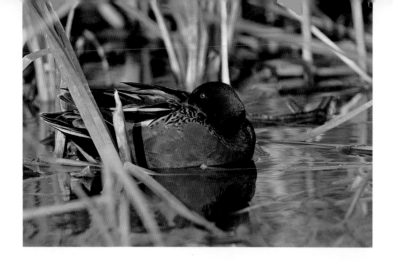

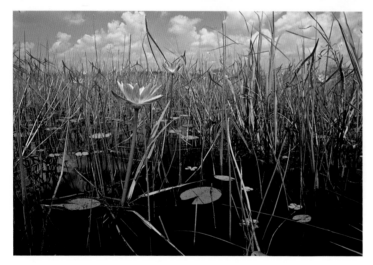

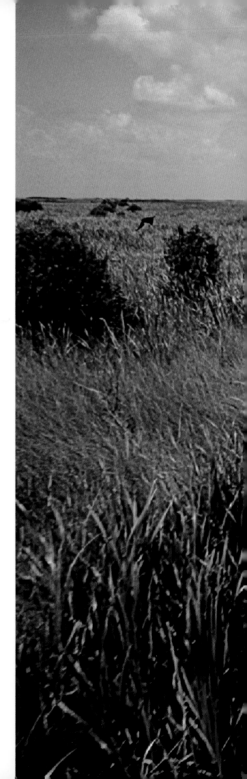

Above, top: A male cinnamon teal rests in a marsh near Port Aransas. Although cinnamon teal breed in the west during the summer, a few winter along the Texas coast, as do many other North American ducks.

Above, bottom: Water lilies adorn this freshwater marsh on the upper Texas coast.

Right: An airboat is the ideal way to traverse the channels in the freshwater marsh at McFaddin National Wildlife Refuge. The refuge holds the largest remaining freshwater marsh on the Texas coast.

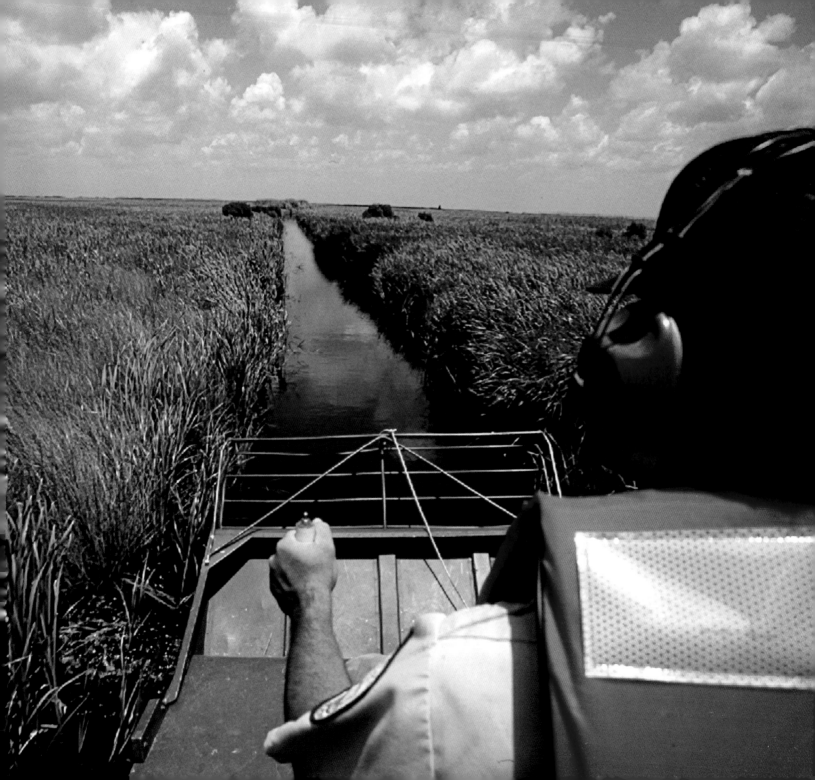

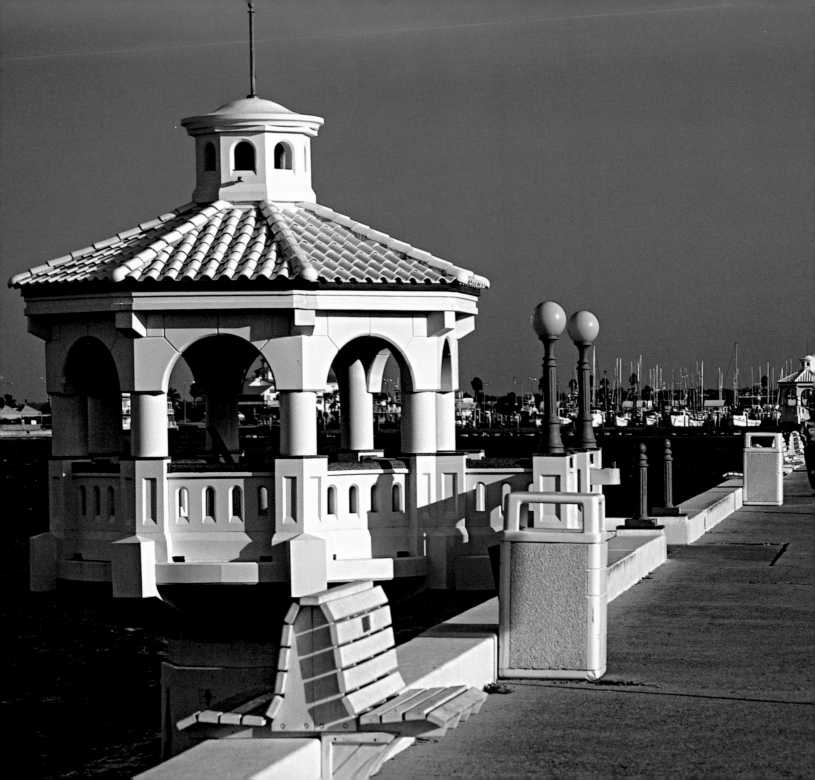

Left: Elegant gazebos line Corpus Christi's public marina. The city is the largest on the Texas coast and the sixth largest port in the nation.

Below: A statue of Victory stands atop the Texas Heroes Monument on Galveston Island. Henry Rosenberg, a Galveston philanthropist, donated the monument to the State of Texas in 1900 to commemorate the achievements of great men and women in the state.

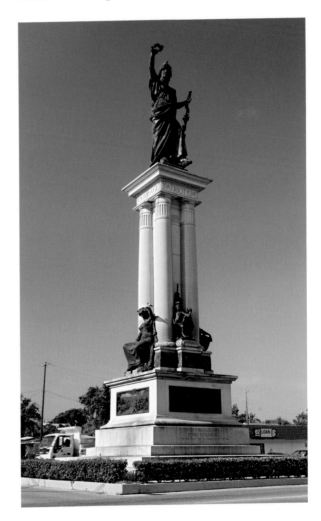

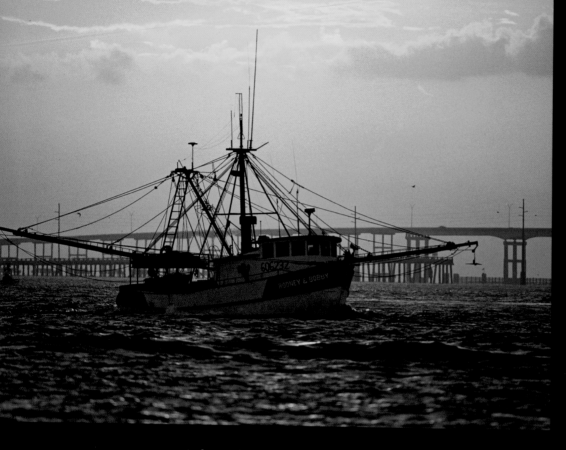

Above: A shrimp boat returns to its Texas port at sunset.

Right: The JFK Causeway spans the Laguna Madre off Corpus Christi Bay.

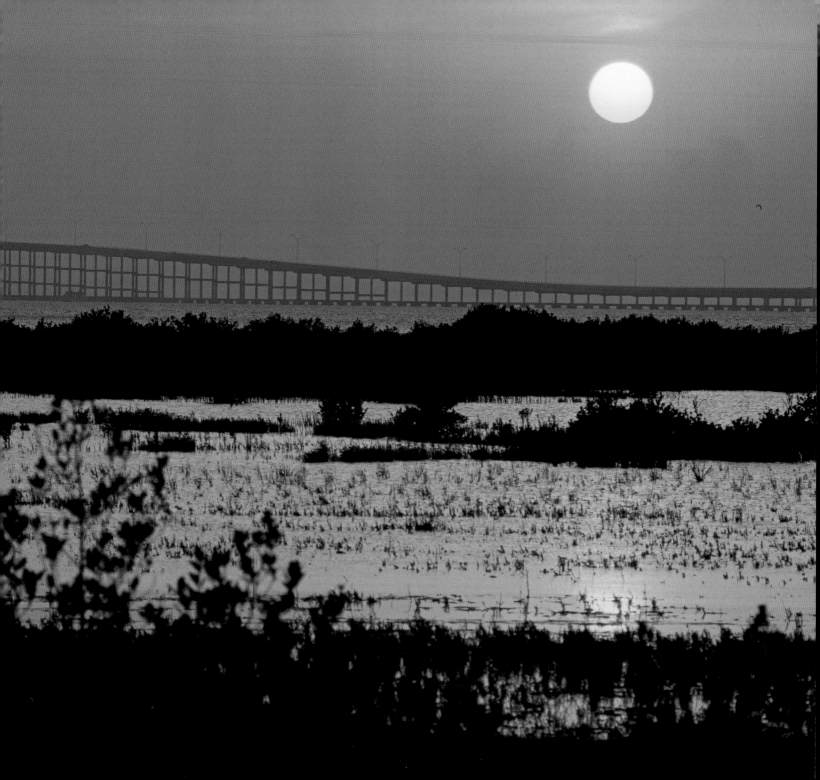

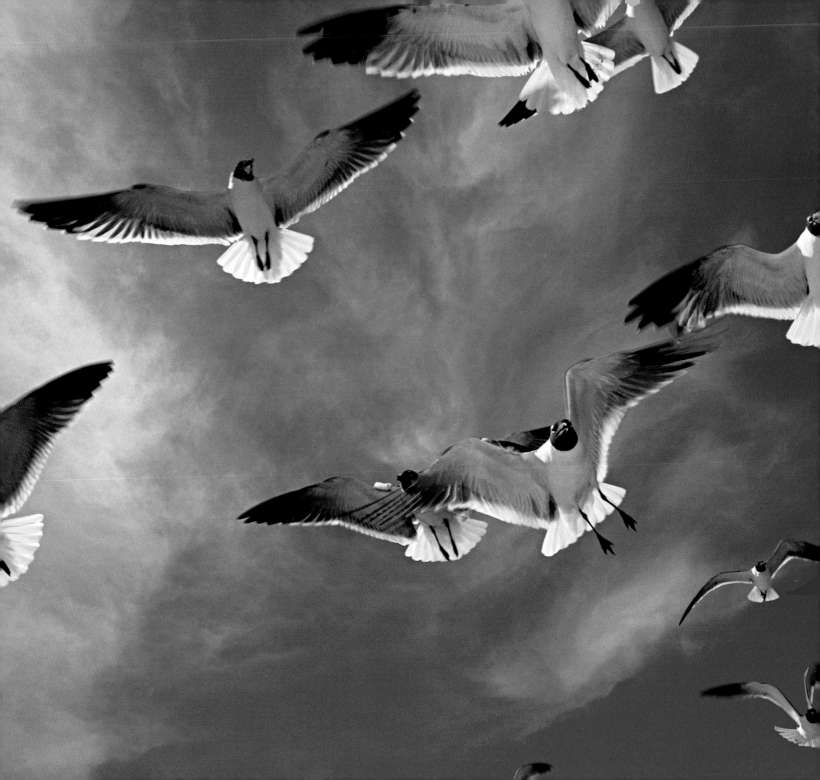

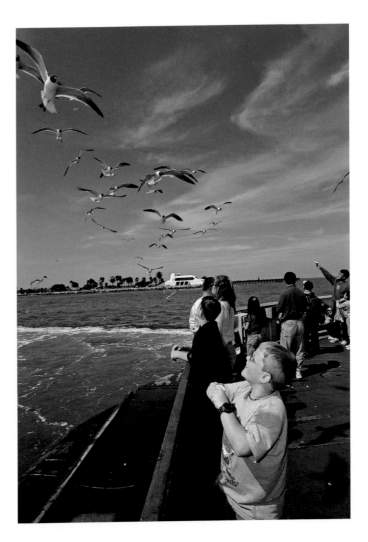

Above: Gleeful children feed gulls off the back of the Galveston ferry.

Left: Gulls take to the sky on a warm summer day.

Right: One of the largest live oak trees in the nation, "Big Tree" at Goose Island State Park on Aransas Bay is more than 1,000 years old. Its circumference is 35 feet at the base, and its crown spreads 90 feet across.

Below: A green heron stalks fish in a shallow pond.

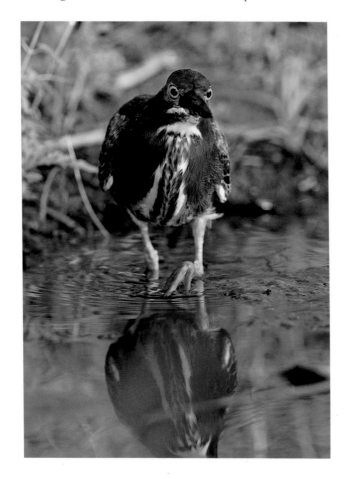

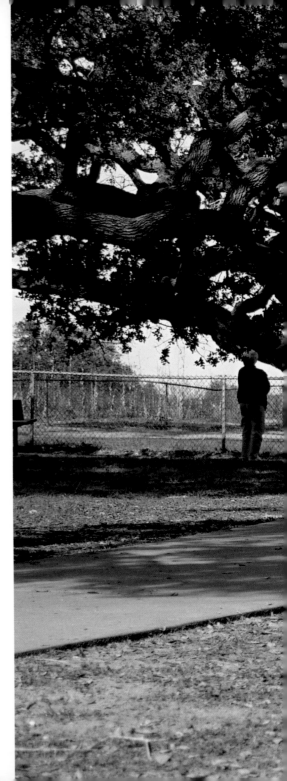

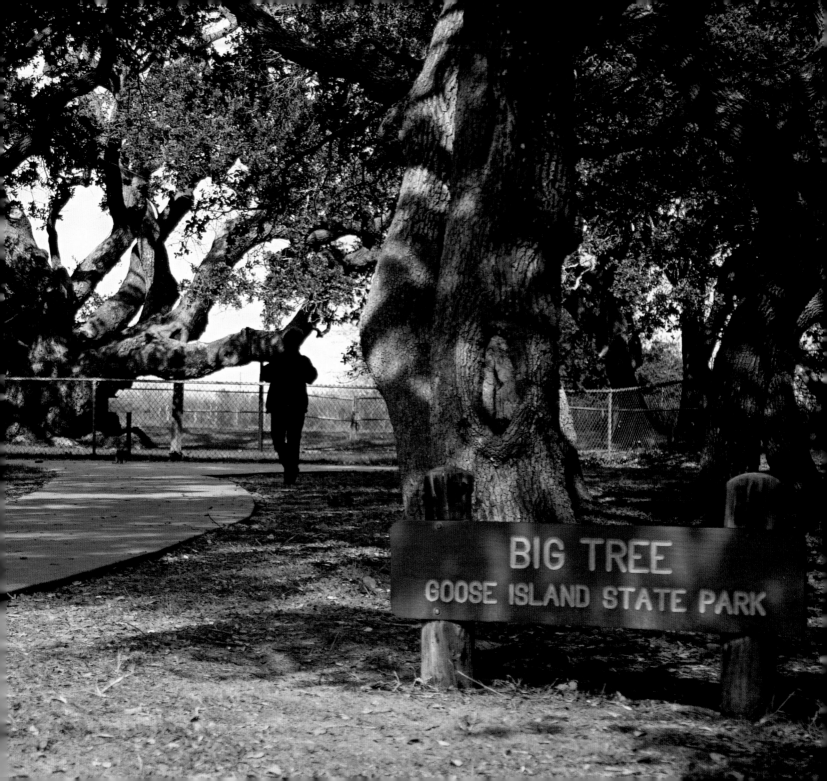

BIG TREE
GOOSE ISLAND STATE PARK

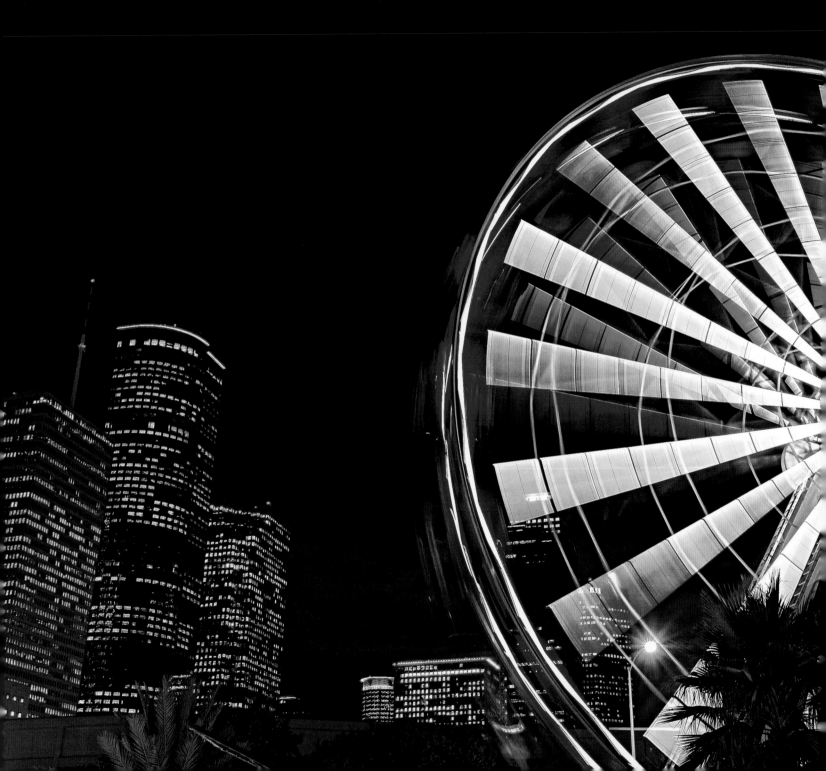

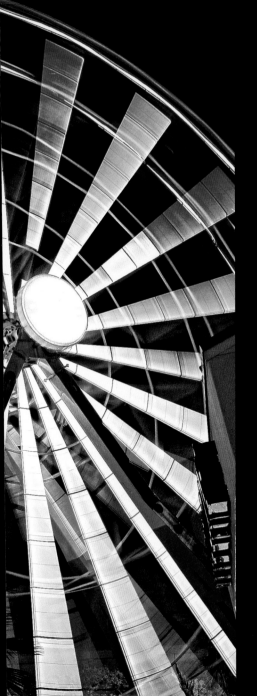

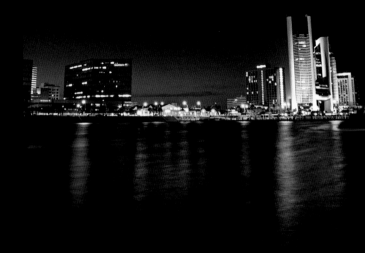

Above: Downtown Corpus Christi lights up the night sky.

Left: The Ferris wheel at the Aquarium Restaurant in Houston's theater district puts on a brilliant light show, with the city's skyline as a backdrop.

Right: Sunlight glints off a freighter as it leaves the Houston Ship Channel and heads for the open sea.

Below: A pelican takes flight over a coastal marsh at the Welder Wildlife Refuge.

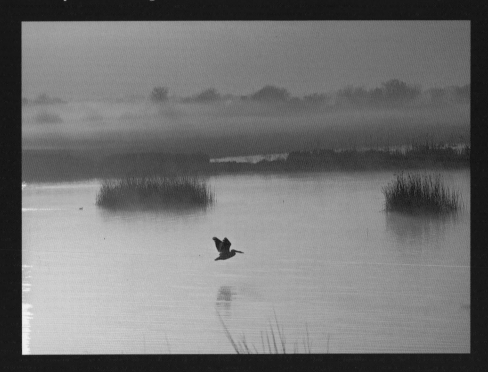

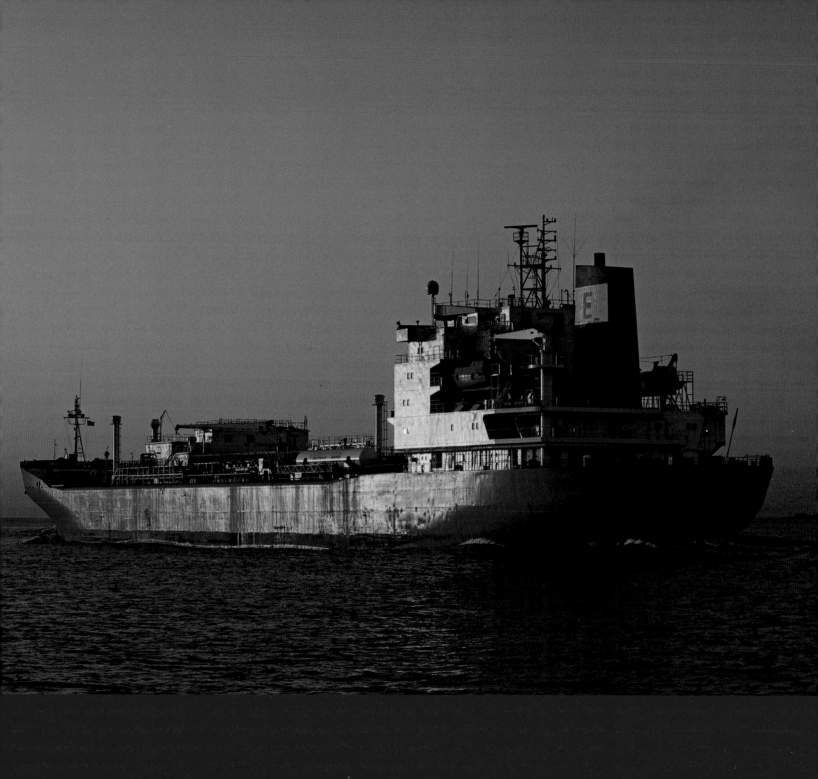

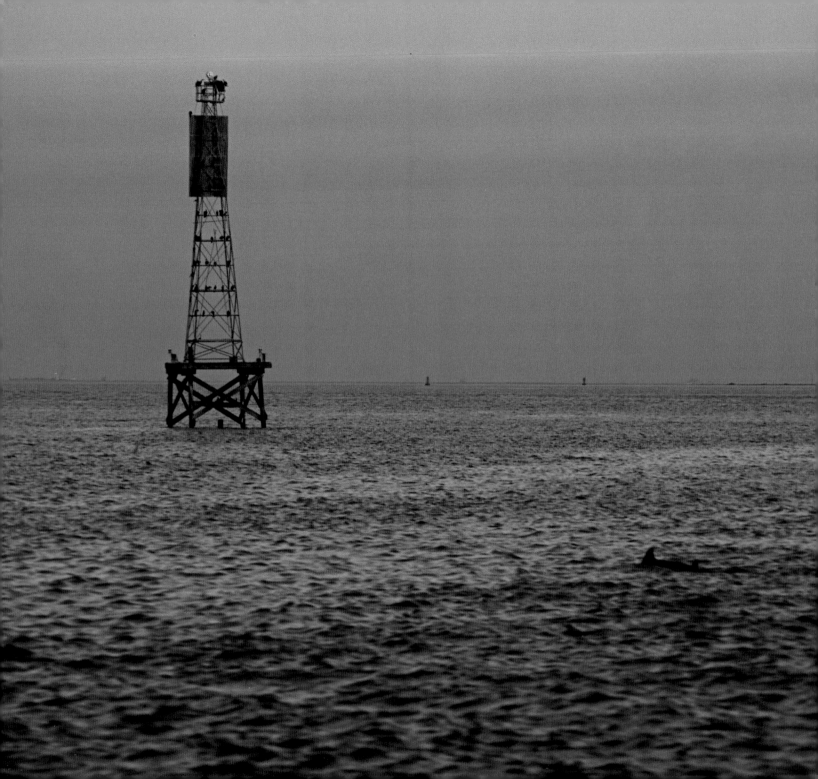

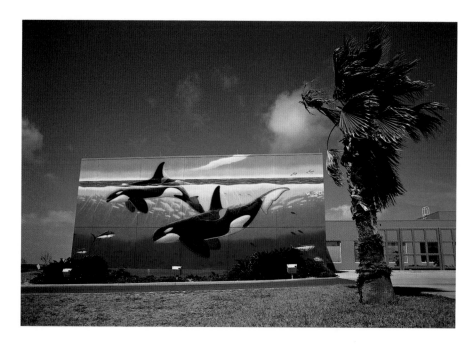

Above: Well-known artist Robert Wyland painted this mural entitled *Whaling Wall #53* on the South Padre Island Convention Center. Dedicated in 1994, the mural is 265 feet across and two and a half stories high.

Left: Bottlenose dolphins surface near a channel marker at the Galveston ferry landing.

Right: A long line of beach umbrellas shades visitors at a Galveston beach.

Below: Sculptor Kent Ullberg created this fifteen-foot-tall bronze sculpture titled *It is I* at the First United Methodist Church in Corpus Christi. The statue depicts Jesus on a boat exerting a calming influence over the bay.

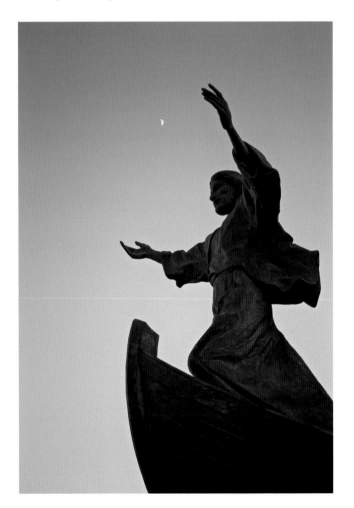

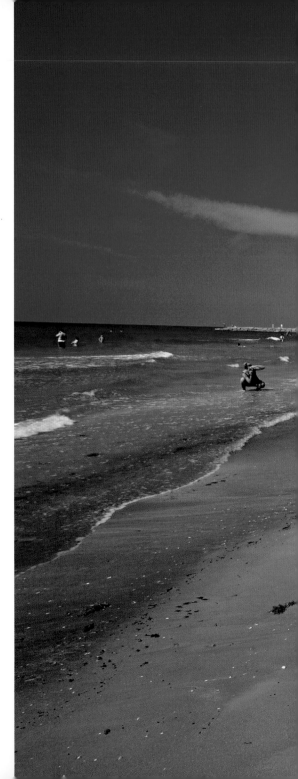

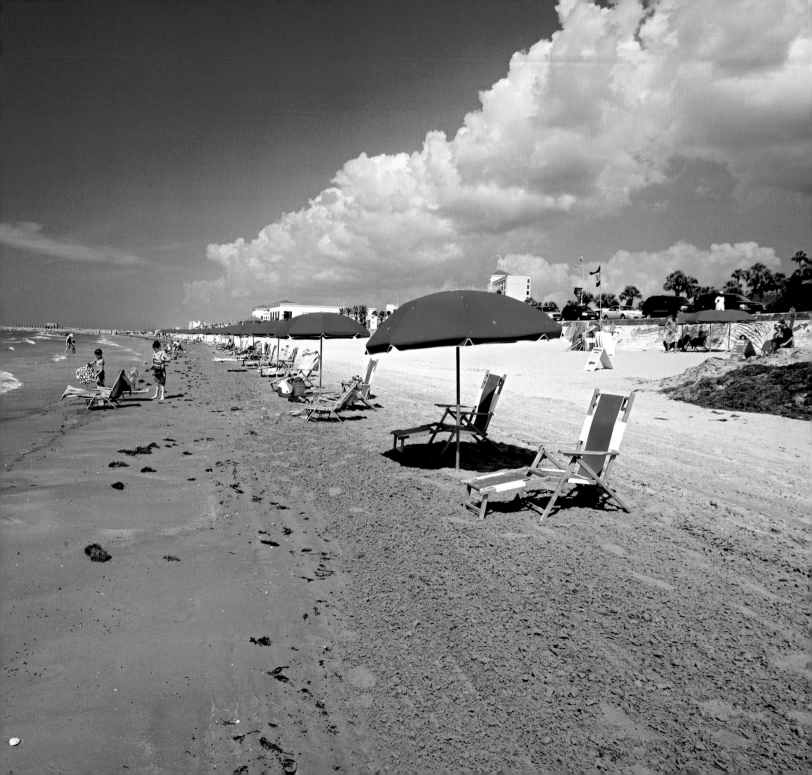

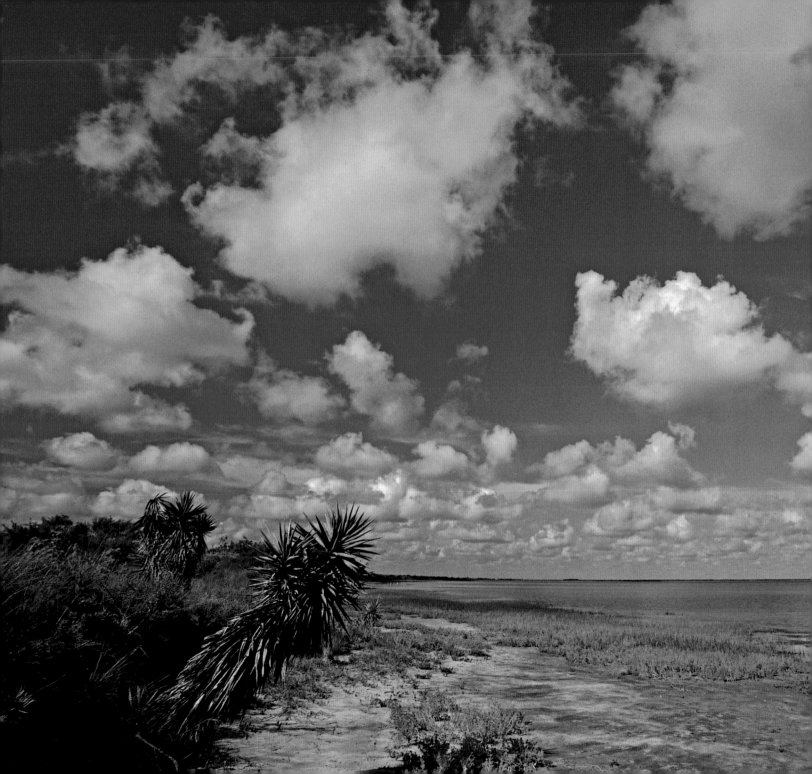

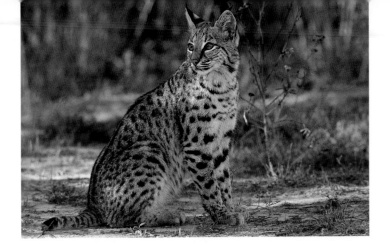

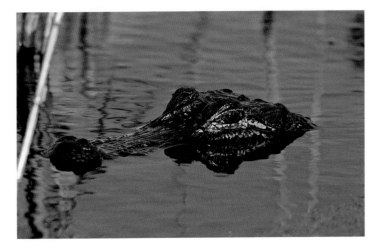

Above, top: Elusive and shy, bobcats are rarely seen but inhabit the entire Texas coast.

Above, bottom: The American alligator, here with only eyes and nostrils above the water's surface, can reach a length of fourteen feet.

Left: Bayside Drive offers this tranquil view of Laguna Madre at the Laguna Atascosa National Wildlife Refuge, which is situated on the southern end of the Texas coast.

Following pages: The skyline of South Padre Island appears in the distance in this view of Laguna Madre from Laguna Atascosa National Wildlife Refuge.

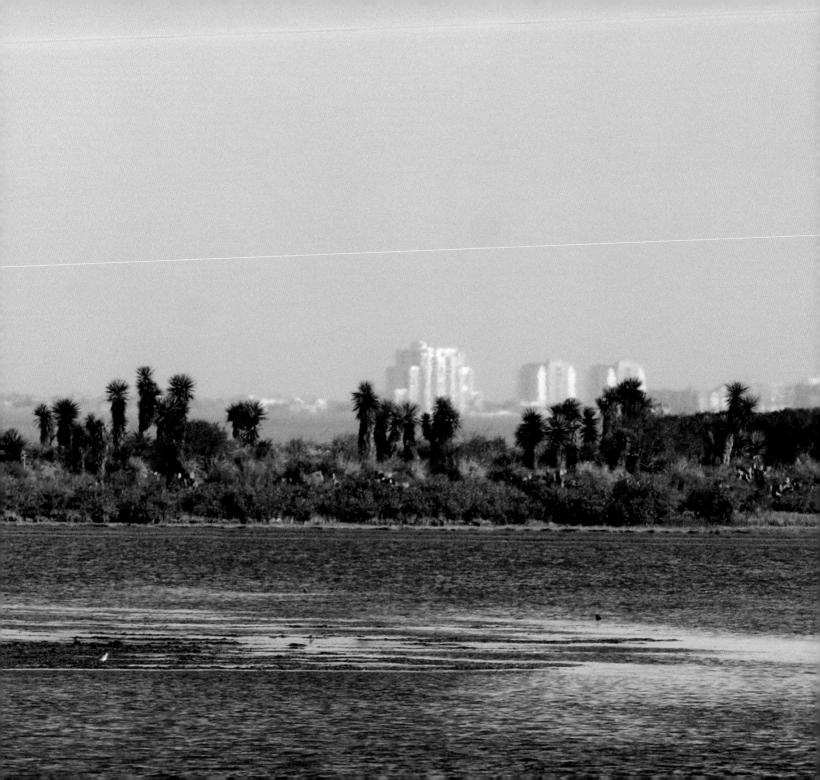

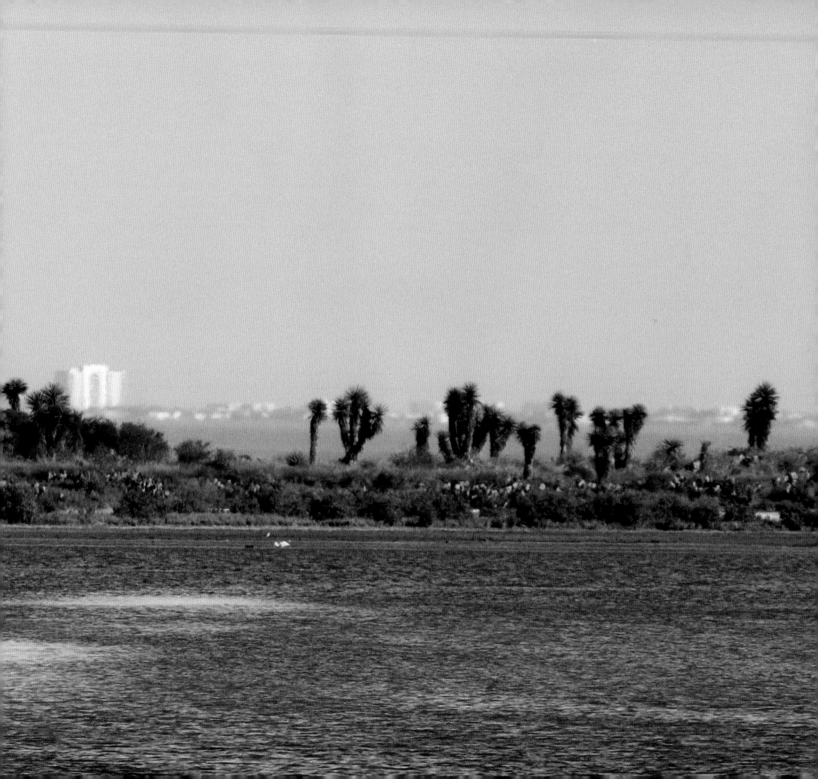

Right: A couple strolls on the South Padre Island beach at twilight.

Below: This aerial view of South Padre Island shows the hotels, condominiums, nightclubs, and vacation homes that attract year-round visitors to the island's mild climate and white sandy beaches.

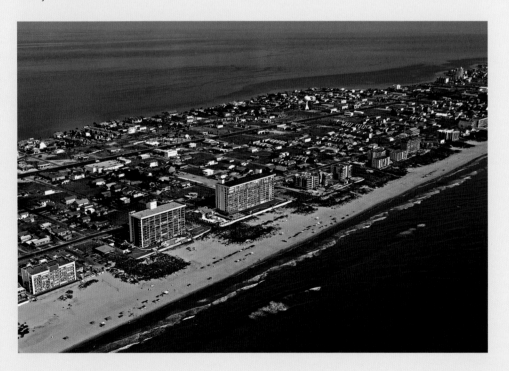

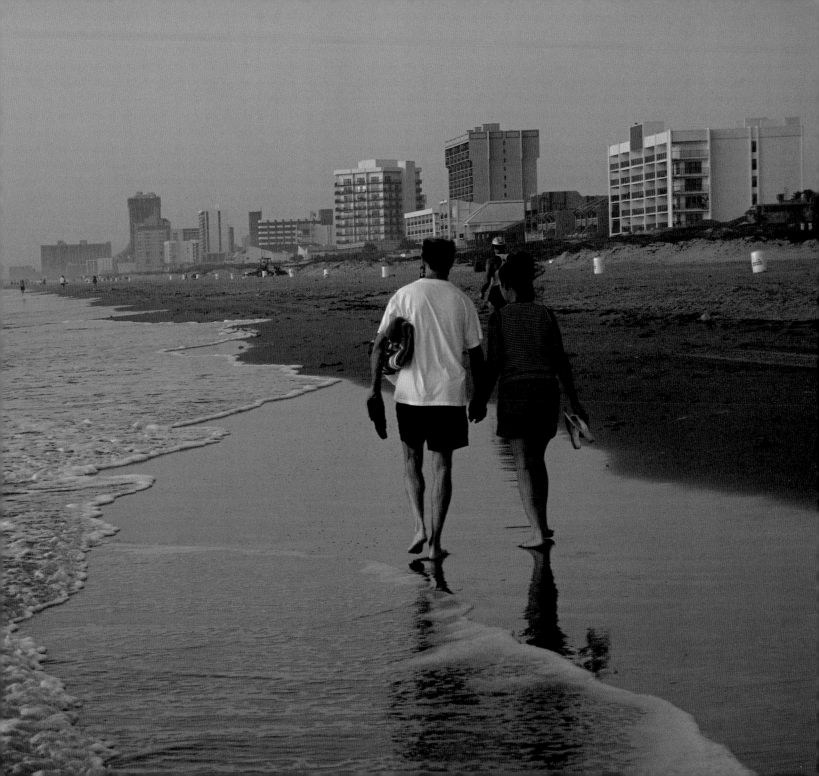

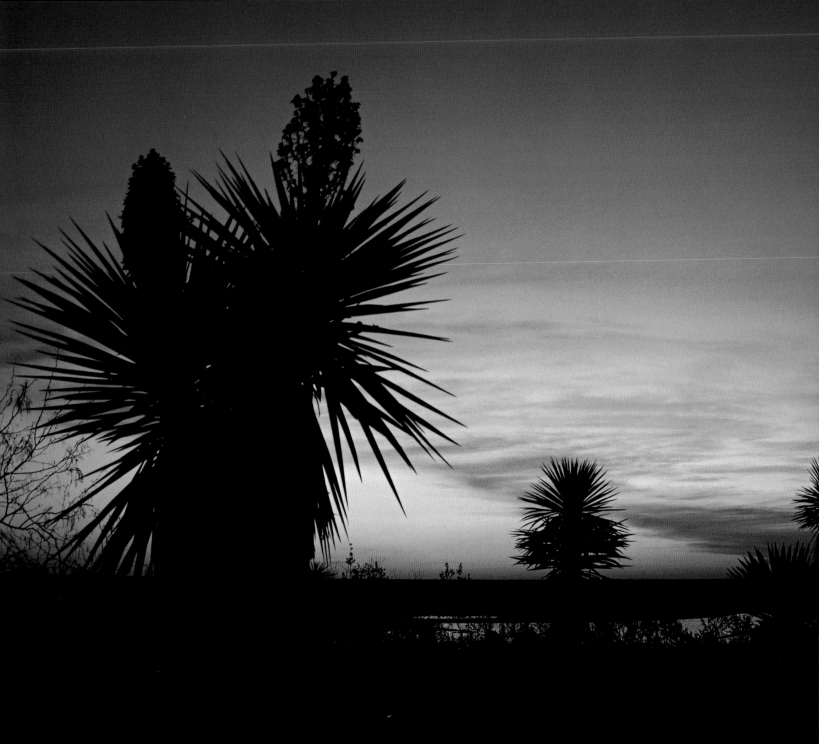

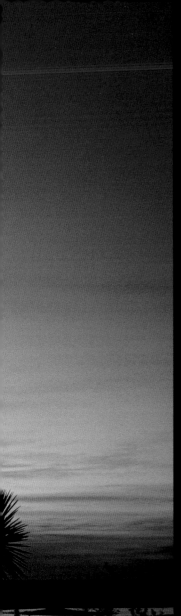

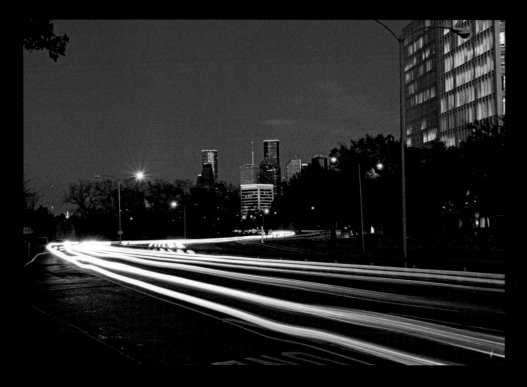

Above: Traffic blurs on the Allen Parkway in Houston.

Left: The spiked silhouette of Spanish dagger yucca appears against a vivid sunset.

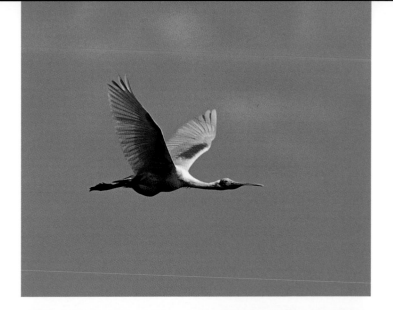

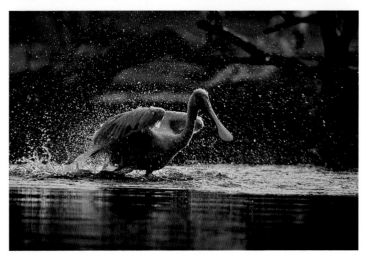

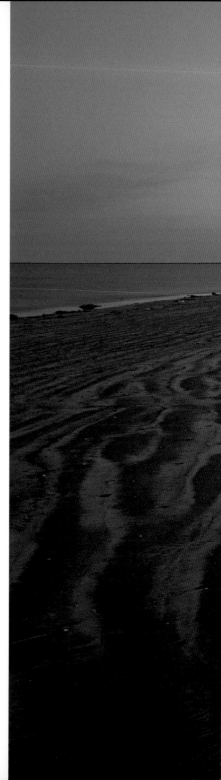

Above, top and bottom: Roseate spoonbills—one flying and one bathing.

Right: The Houston Audubon Society's internationally acclaimed Bolivar Flats Shorebird Sanctuary on Bolivar Peninsula is awash in pastels at twilight.

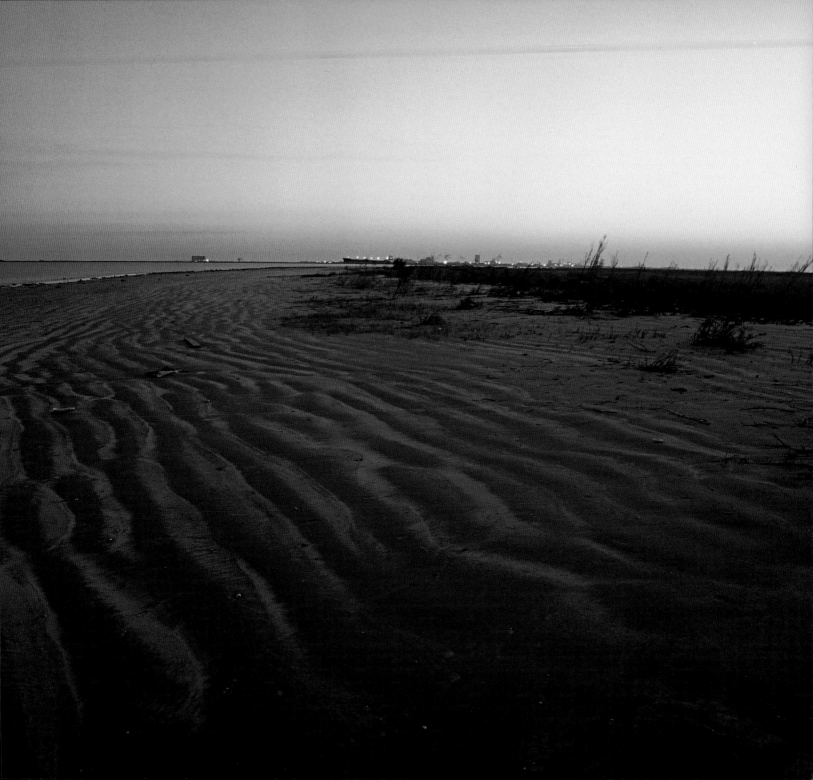

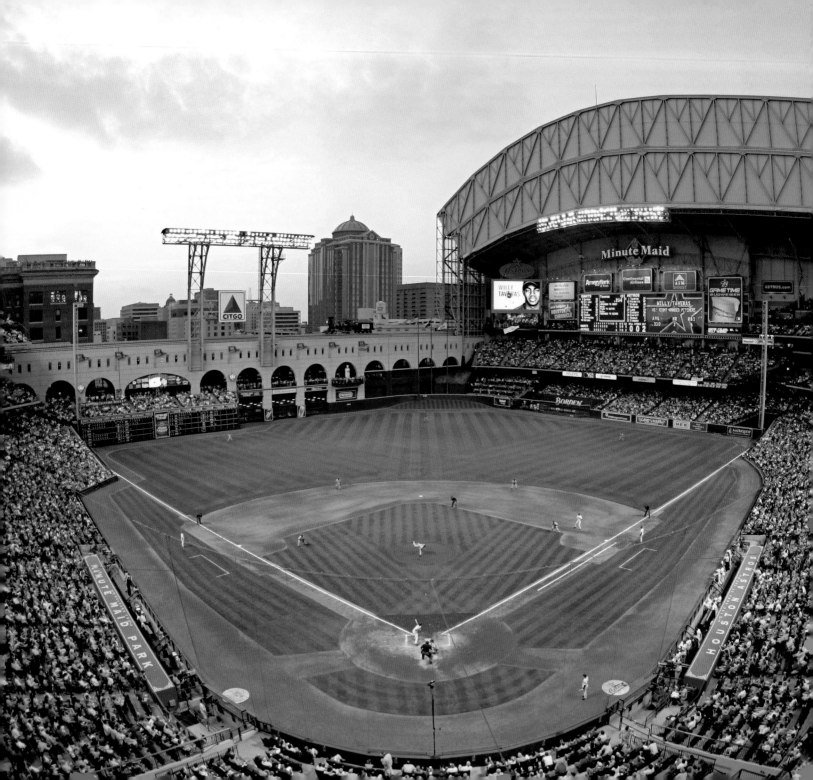

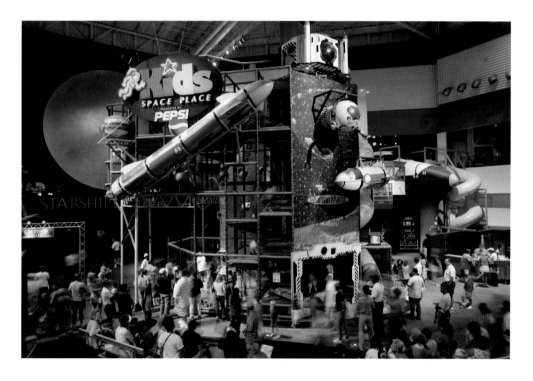

Above: Tourists flock to Space Center Houston, the official visitor center for NASA's Johnson Space Center.
PHOTO COURTESY OF ANOTHER OFF THE WALL PRODUCTION, INC./NASA SPACE CENTER HOUSTON.

Left: Minute Maid Park, home of the Houston Astros baseball team, stands in downtown Houston.
PHOTO COURTESY OF THE HOUSTON ASTROS.

Right: The Houston Museum of Natural Science in Hermann Park features exceptional exhibits, an IMAX theater, a glass-enclosed butterfly house, and a planetarium.

Below: The world's tallest war memorial, the 570-foot San Jacinto Monument stands as a tribute to those who fought for Texas's independence from Mexico in 1836.

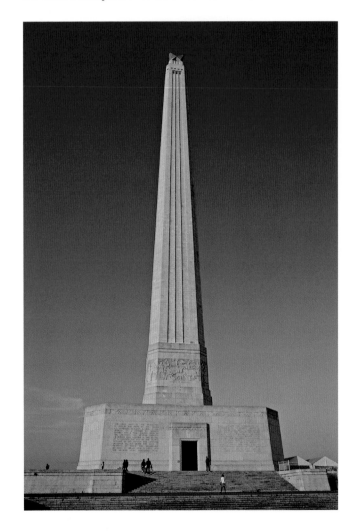

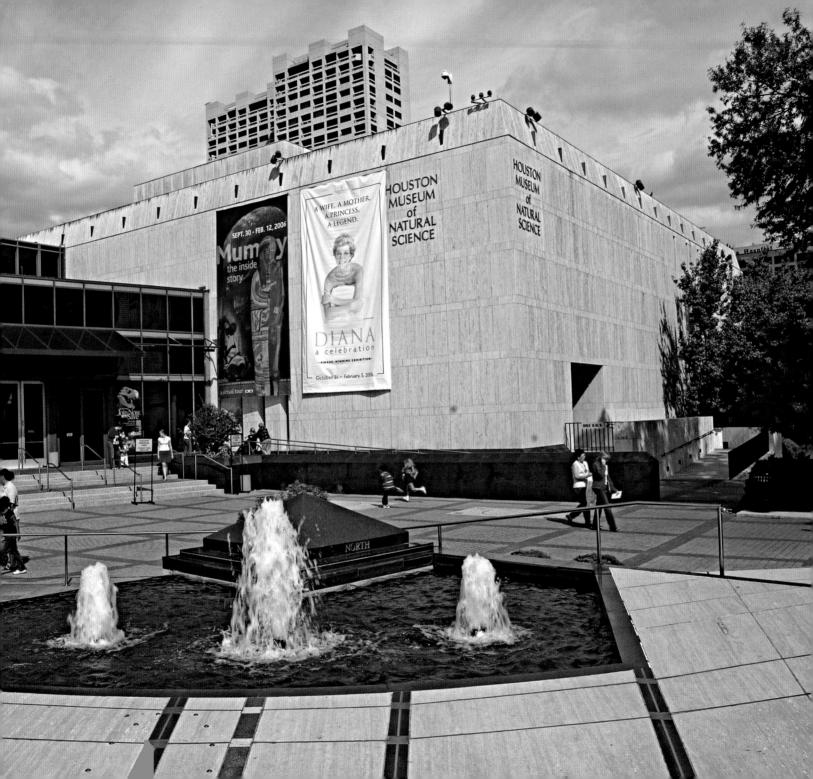

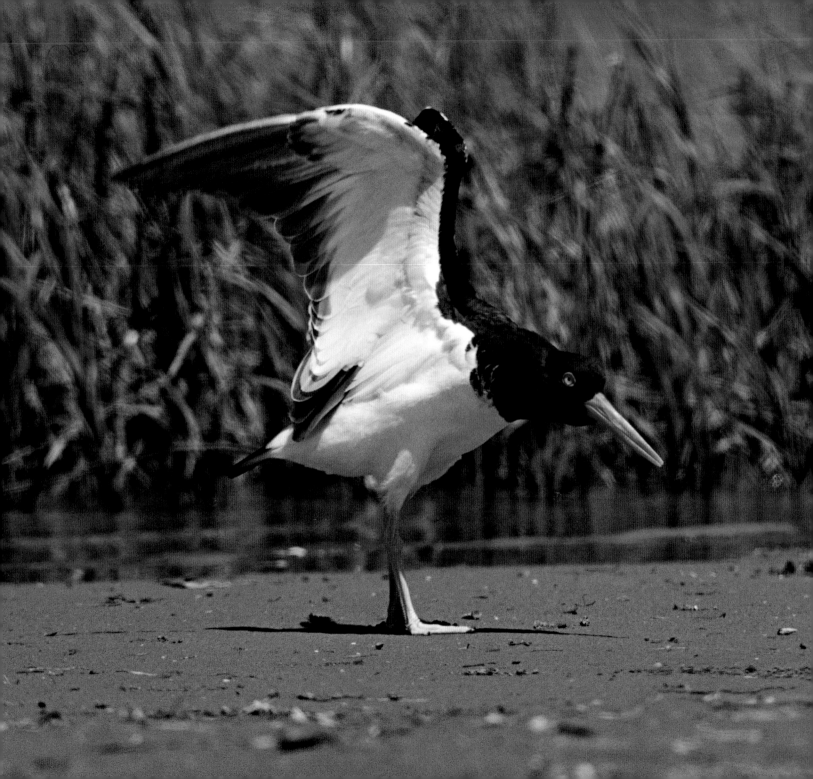

Above: Bluestem grass sways in the breeze on a coastal prairie.

Left: An American oystercatcher stretches its wings on a Texas beach.

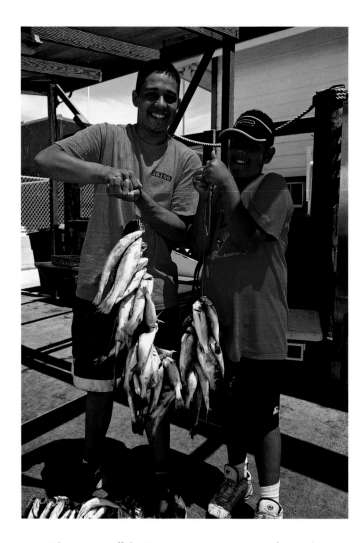

Above: The waters off the Texas coast are a magnet for anglers of all ages.

Right: A commercial fishing boat plies the coastal waters for the catch of the day.

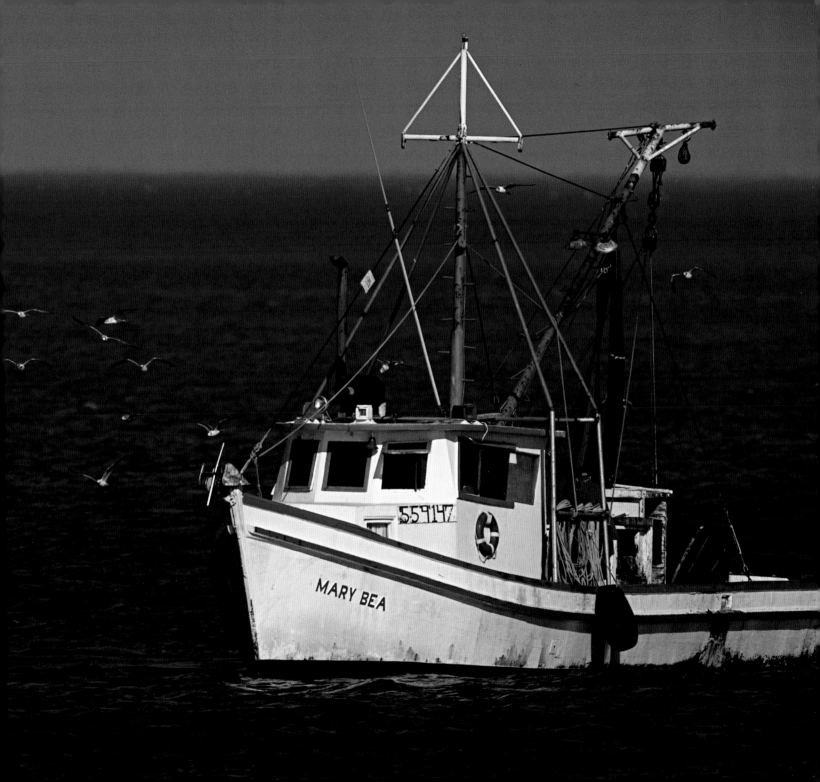

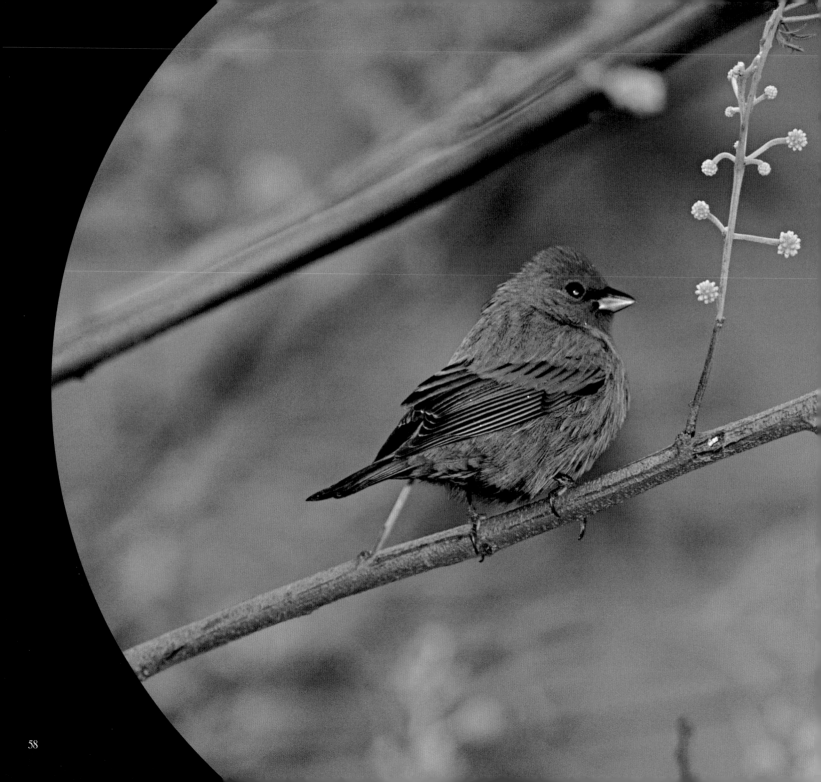

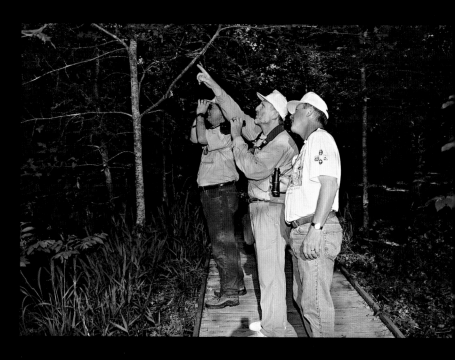

Left: This gorgeous indigo bunting is an example of the many neotropical birds that migrate from Central and South America to Texas in the spring.

Below: Migratory birds draw birdwatchers from around the world to the Texas coast.

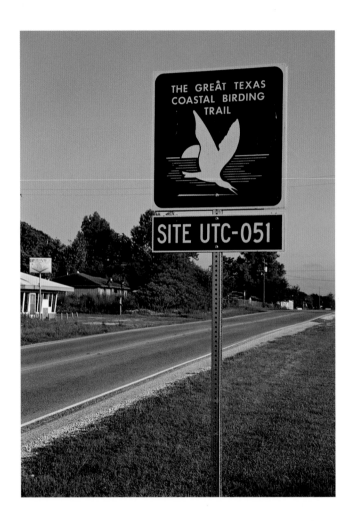

Above: The Great Texas Coastal Birding Trail winds through 308 different birdwatching locations along the Texas coast.

Right: A dowitcher wades in shallow coastal waters.

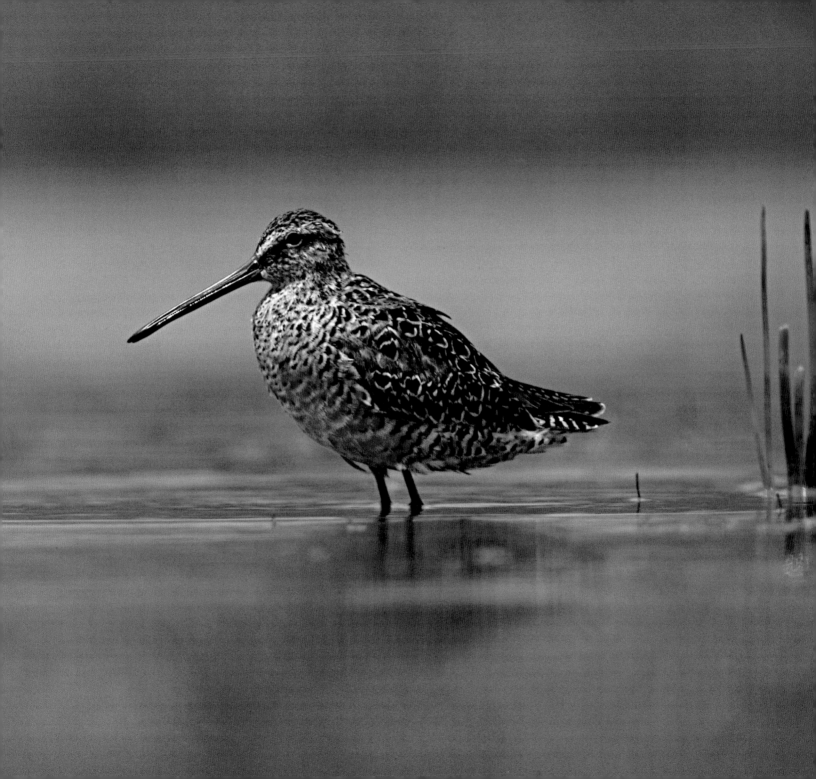

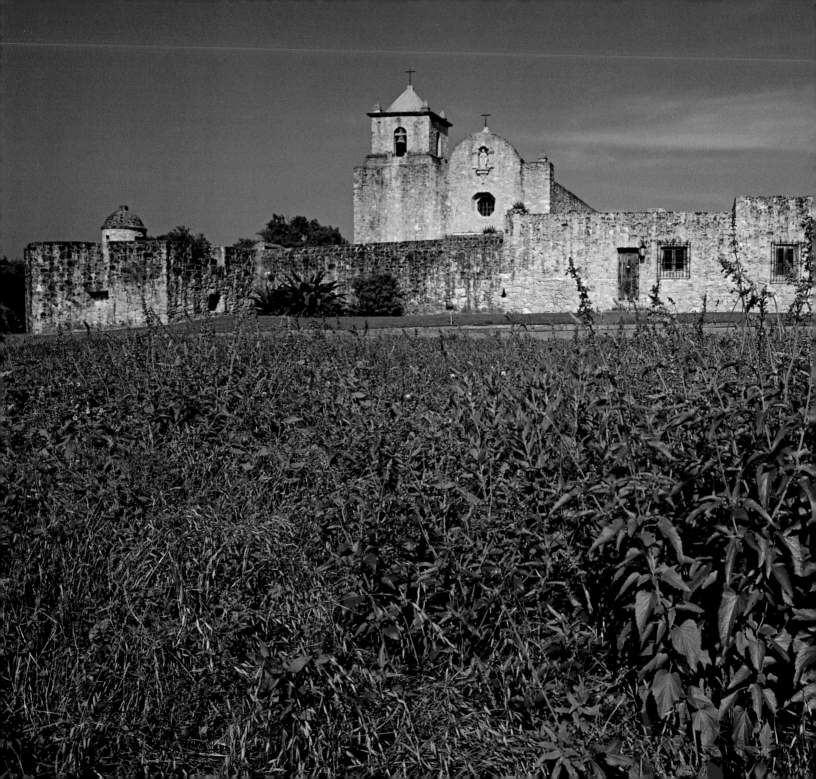

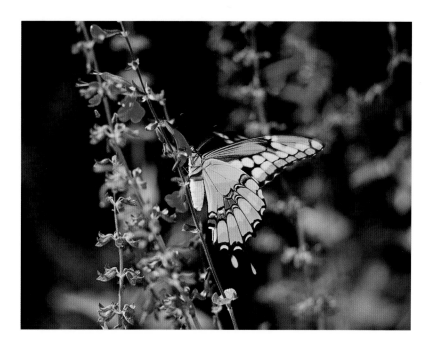

Above: A giant swallowtail butterfly alights on a salvia stem to feed. Butterflies flutter throughout the Texas coast year-round because of the warm, semi-tropical climate.

Left: The Presidio La Bahia was built near Goliad in 1749. Soldiers stationed at the presidio helped the Spanish Army fight the British during the American Revolution. During the Texas Revolution of 1835 to 1836, the presidio was under the control of those loyal to the Texas cause. Restoration of the presidio began in 1963 and it now stands as a living history museum.

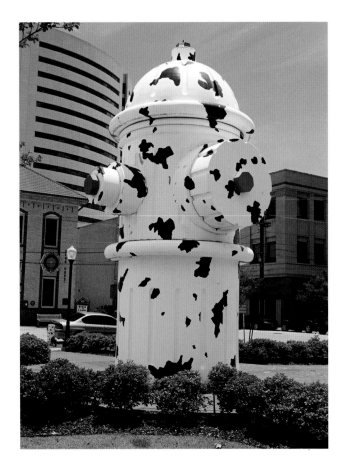

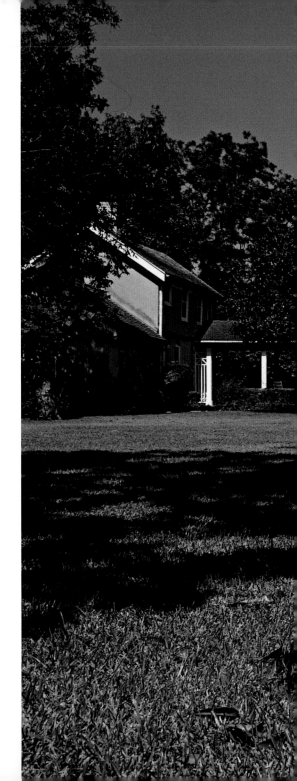

Above: This giant fire hydrant, once used to promote the Disney film *101 Dalmatians,* found a permanent home at the Firefighters Memorial Plaza in downtown Beaumont. The plaza features a brick walkway with the names of Texas firefighters, living and deceased. Also in the plaza is a memorial to the firefighters killed in New York City on September 11, 2001.

Right: The grounds of Los Ebanos Preserve near San Benito on the lower Texas coast are a popular wildlife sanctuary, and the main house is a favorite venue for private parties and receptions.

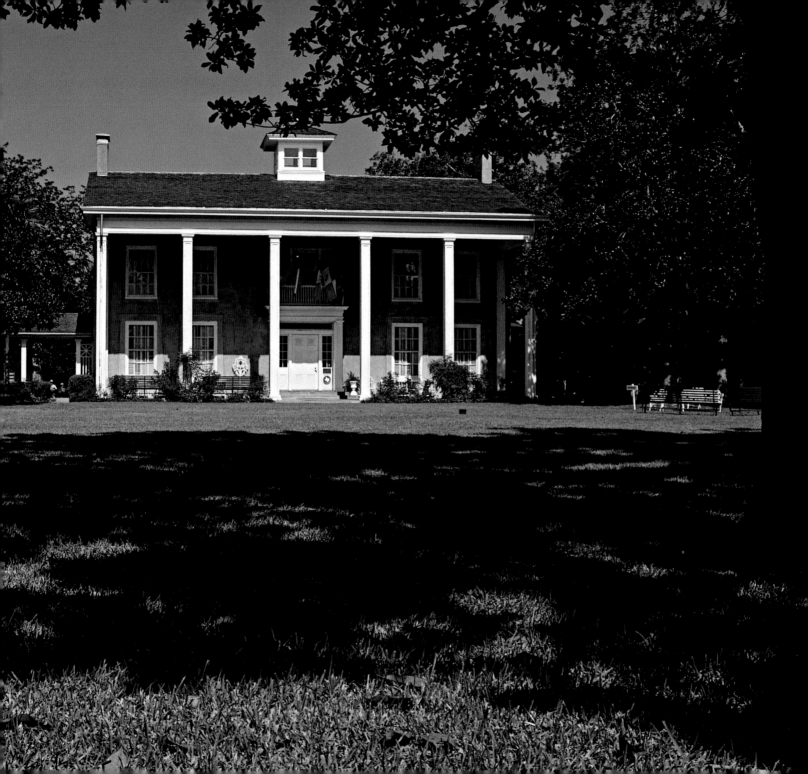

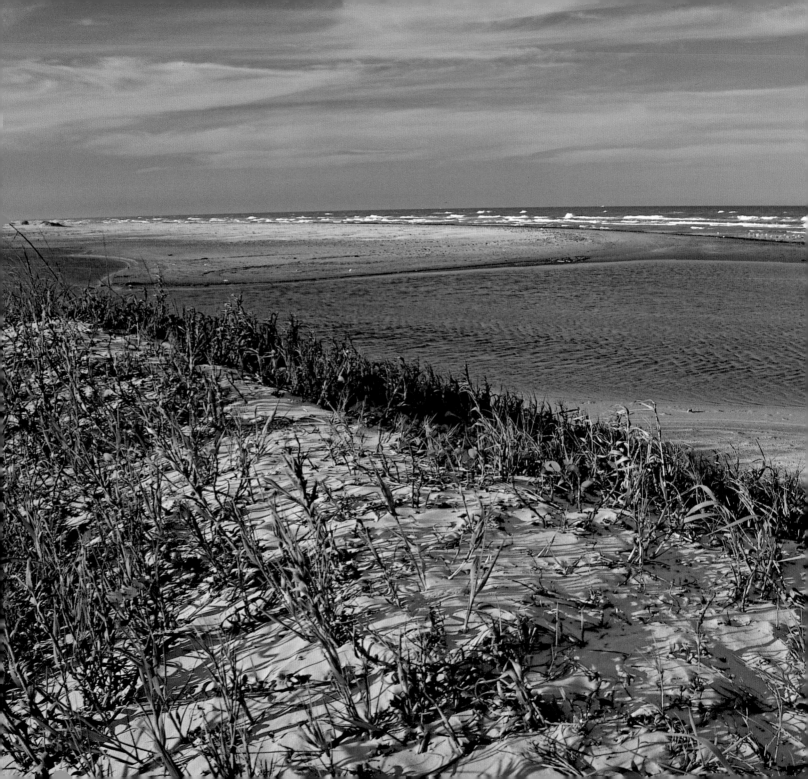

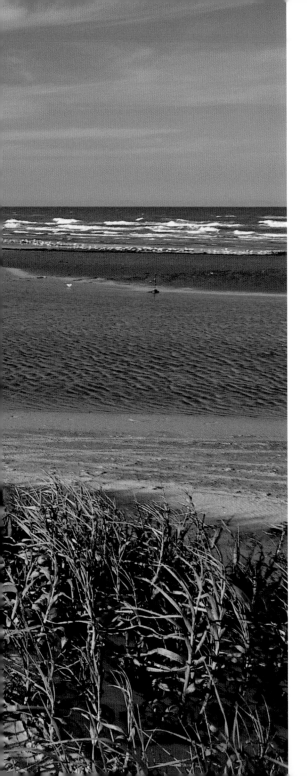

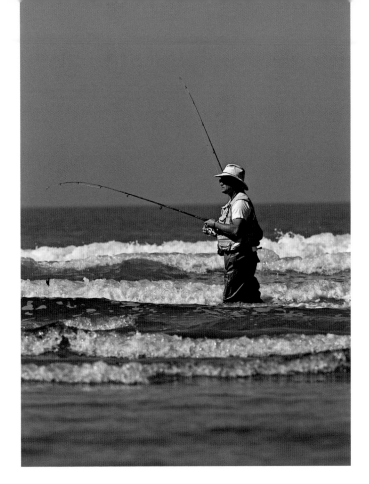

Above: The shallow waters off Padre Island are a popular site for surf fishing.

Left: The sand dunes, tidal pools, and shoreline of Padre Island National Seashore provide a home for a wide variety of creatures and plants.

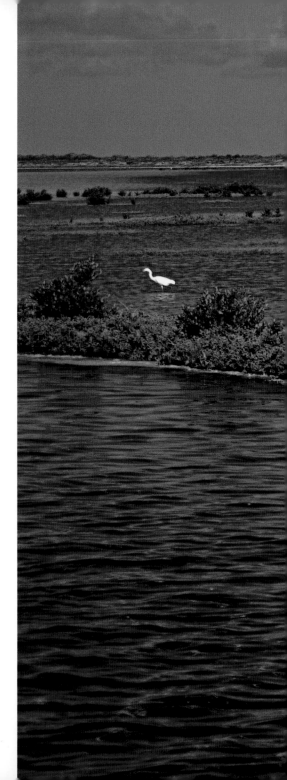

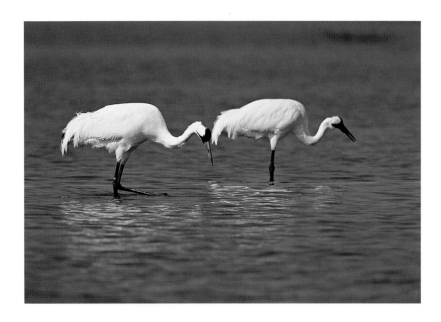

Above: Endangered whooping cranes have made a remarkable comeback thanks to the protection of their wintering grounds at the Aransas National Wildlife Refuge on the central Texas coast.

Right: A kayaker watches a great egret in a coastal marsh.

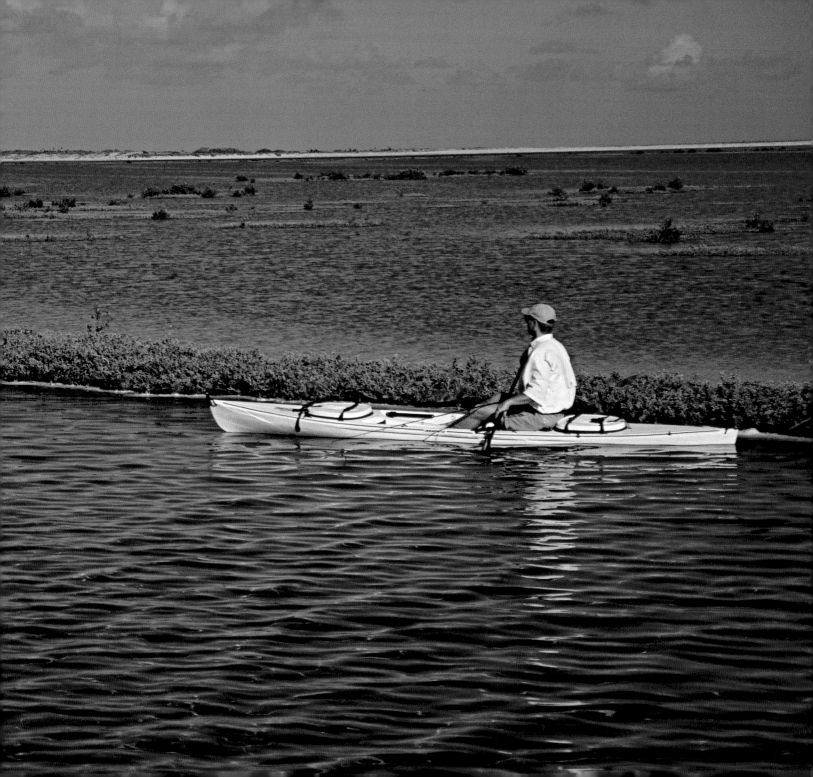

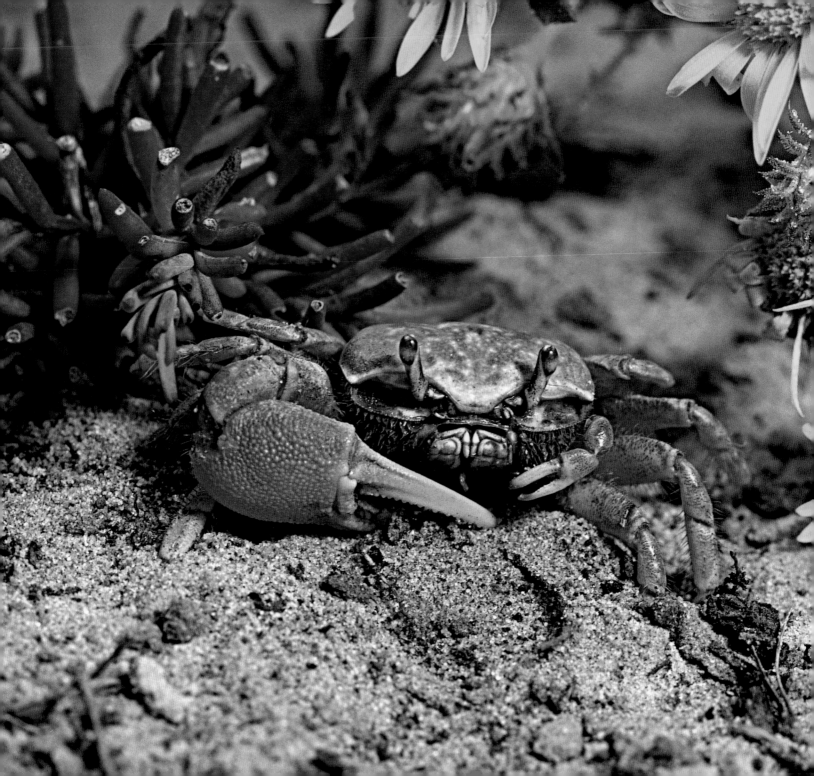

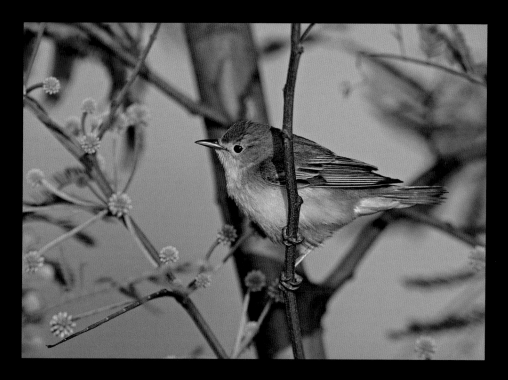

Above: A yellow warbler, one of many neotropical migrants that visit the Texas coast in the spring, perches in a coastal woodland.

Left: A land crab hides among spring wildflowers on the coast.

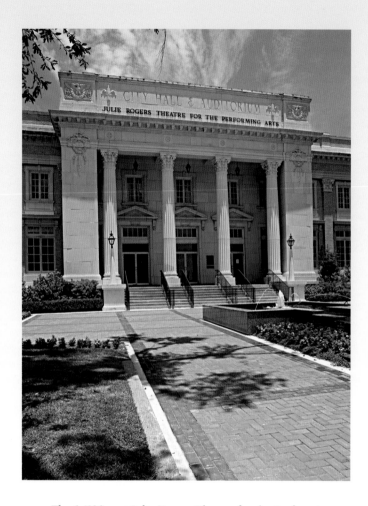

Above: The 1,700-seat Julie Rogers Theatre for the Performing Arts in Beaumont is home of the Symphony of Southeast Texas, Beaumont Civic Opera, and Beaumont Ballet Theatre.

Right: Live oak trees wrapped in lights bring a festive glow to Hermann Square on the grounds of City Hall in downtown Houston.

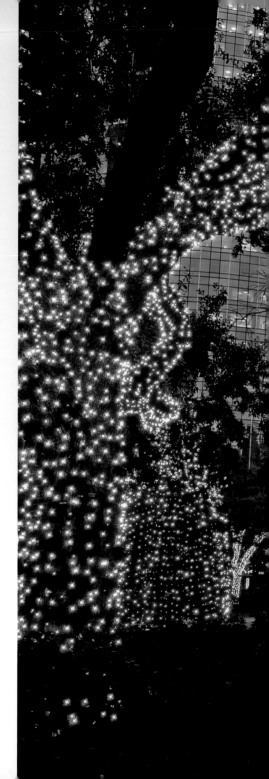

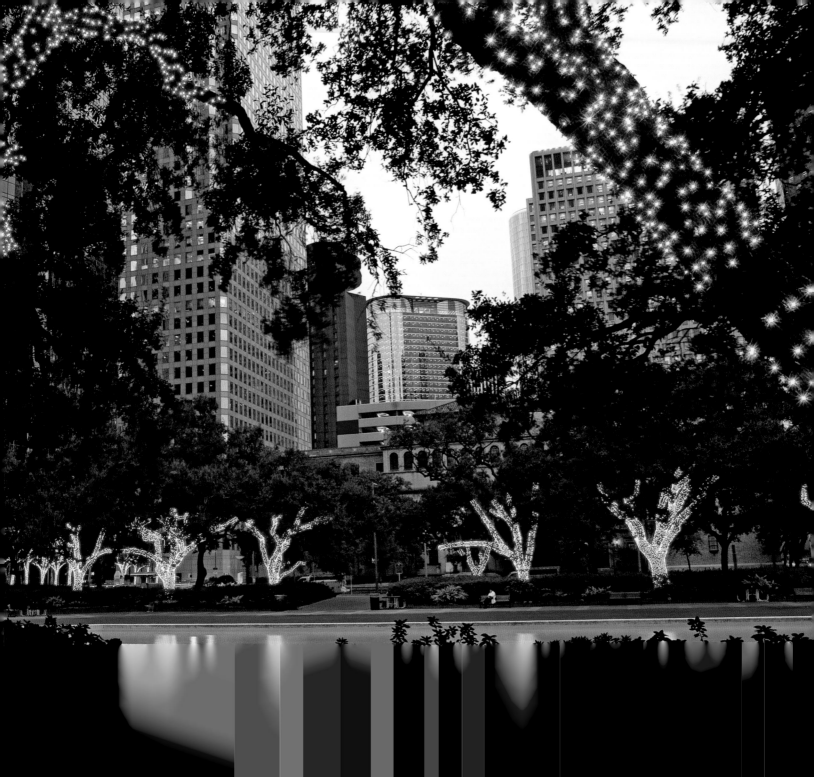

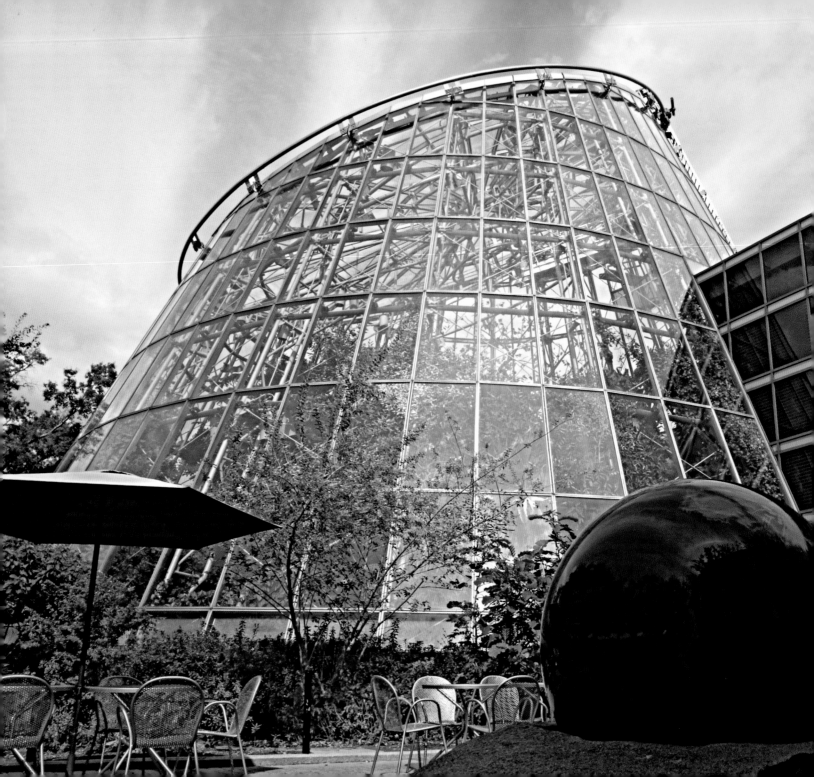

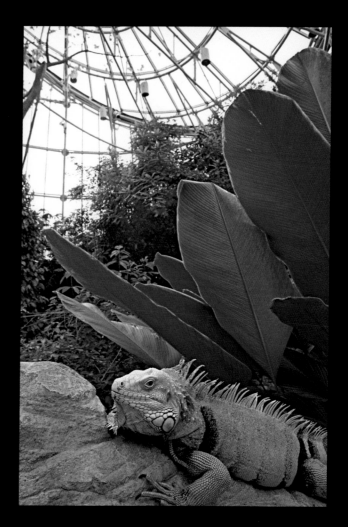

Above: A green iguana suns itself on a rock in the Cockrell Butterfly Center at the Houston Museum of Natural Science in Hermann Park.

Right: Anglers fish along the Texas coast as the sun drops toward the horizon.

Below: Pelicans find the shallow waters of a coastal marsh a safe haven at eventide.

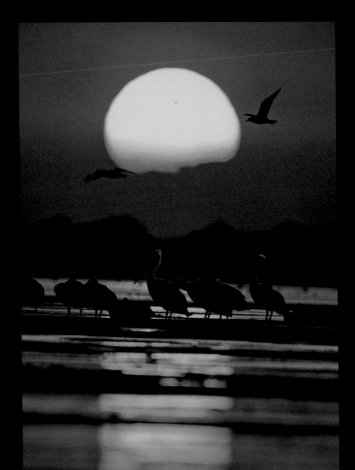

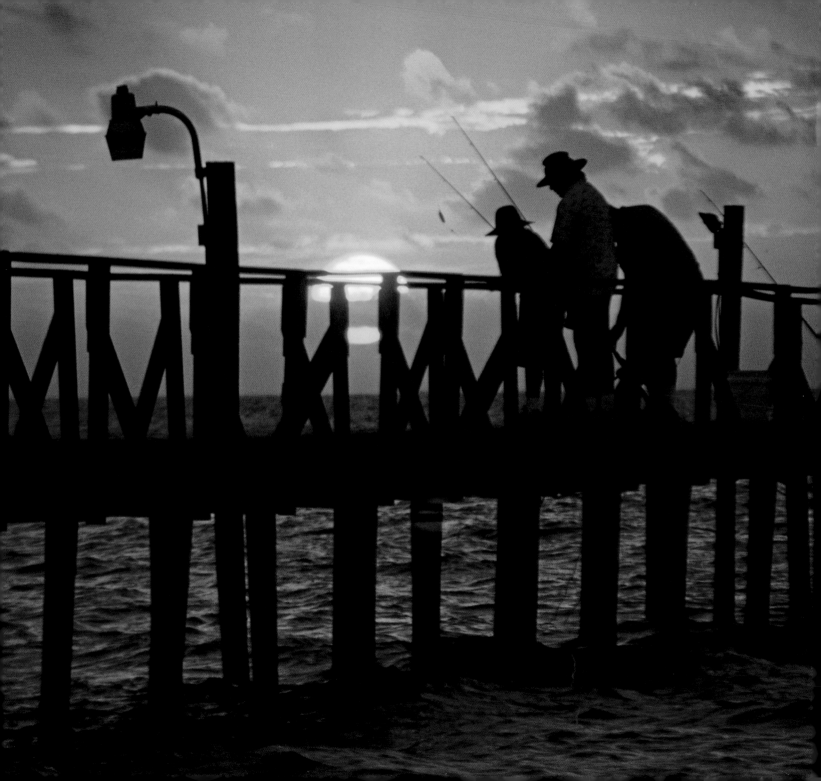

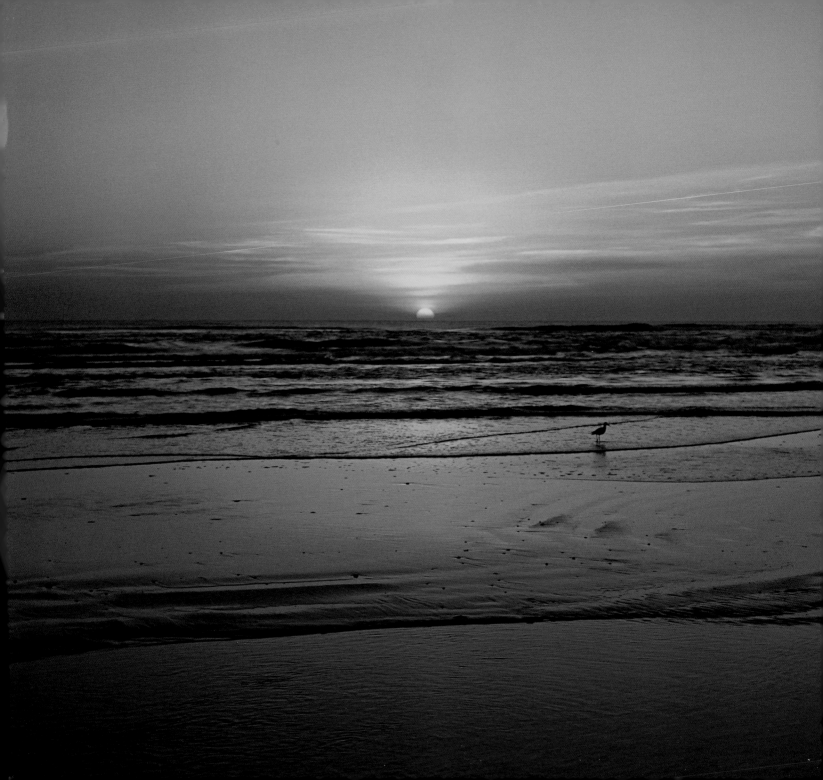

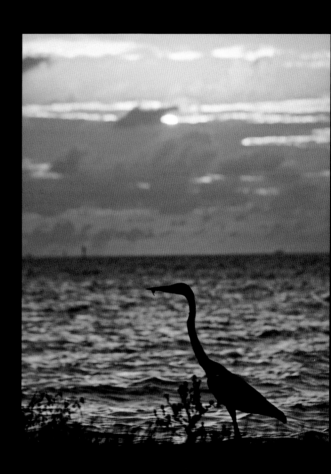

Above: A great egret is silhouetted against the setting sun on the Texas coast. The coast averages more than 250 days of sunshine per year, with at least as many stunning sunsets.

Left: This serene sunrise on South Padre Island promises another splendid day on the Texas coast.

GREG LASLEY

LARRY DITTO

KATHY ADAMS CLARK

GLENN HAYES

GARY CLARK

Greg Lasley, Larry Ditto, Kathy Adams Clark, and Glenn Hayes are professional nature photographers who have spent many years photographing in Texas. Their work is regularly published in *Texas Parks & Wildlife* and *Texas Highways* magazines as well as in such national magazines as *Nature's Best, National Wildlife, Ranger Rick,* and *Birder's World.* Kathy Adams Clark is the owner of KAC Productions, the stock agency marketing all their work.

Gary Clark is a native Texan, dean at North Harris College, and author of a weekly nature column in the *Houston Chronicle.* His award-winning writing has been published in such magazines as *Texas Parks & Wildlife, Texas Highways, Birds & Blooms, Birder's World,* and *Living Bird.*